The
Huntington

TREASURES
FROM TEN
CENTURIES

Library

by the Director and Curators

The Huntington Library, San Marino, California
in association with Scala Publishers, London

First published in 2004 by the
© Henry E. Huntington Library and Art Gallery
in association with Scala Publishers Ltd.
Northburgh House
10 Northburgh Street
London EC1V 0AT
United Kingdom

ISBN 1-85759-334-0 (Scala)
ISBN 0-87328-206-X (paper)
ISBN 0-87328-205-1 (cloth)

Library of Congress Cataloging-in-Publication Data

The Huntington Library : treasures from ten
centuries / by the director and curators.
 p. cm.
 Includes index.
1. Henry E. Huntington Library and Art Gallery.
2. Rare book libraries—California—San Marino.
3. Rare books—California—San Marino—
Bibliography. 4. Manuscripts—California—San
Marino. 5. Library resources—California—San
Marino. I. Henry E. Huntington Library and
Art Gallery.
Z733.H5 H86 2004
027.7794/93 22 2003027527

Huntington Library Press
Director: Peggy Park Bernal
Editor: Susan Green
Production Coordinator: Jean Patterson

Editor (Scala): Esme West
Designer: Janet James
Photography: Huntington Library Photo Services
 Department (John Sullivan, Senior Photographer;
 Manuel Flores, Photographer; Devonne Topits,
 Library Assistant-Digital Imaging)
Produced by Scala Publishers Ltd.
Printed and bound in China by
 Hong Kong Graphics & Printing Ltd.

CONTRIBUTORS:

Mr. Huntington and His Library: David Zeidberg,
Avery Director of the Library

Medieval and Renaissance Manuscripts and *British
Historical Manuscripts*: Mary L. Robertson, William A.
Moffett Chief Curator, Manuscripts

American Historical Manuscripts: *The Colonial Period through
the Civil War*: John Rhodehamel, Norris Foundation
Curator, American Historical Manuscripts

Western American and California Manuscripts: Peter J.
Blodgett, H. Russell Smith Foundation Curator,
Western American Manuscripts

British and American Literary Manuscripts: Sara S.
Hodson, Curator, Literary Manuscripts

Incunabula and *Books of the British Isles*: Stephen Tabor,
Curator, Early Printed Books

American Books: Alan Jutzi, Avery Chief Curator of
Rare Books

History of Science and Technology: Daniel Lewis,
Curator, History of Science and Technology

Photography: Jennifer A. Watts, Curator, Photographs

Prints and Ephemera: Cathy Cherbosque, Curator,
Historical Prints and Ephemera

Maps: Alan Jutzi, Avery Chief Curator of Rare
Books; Bill Frank, Curator, Hispanic, Cartographic,
and Western Historical Manuscripts

Research and Education: Robert C. Ritchie, W. M. Keck
Foundation Director of Research

Index: Carol B. Pearson

Page 1: Audubon, *The Birds of America* (see page 13)

Page 2: Calendar for the first half of April
 Book of Hours, in Latin
 Illuminated by the Workshop of the Master of
 the Duke of Bedford, France, mid-fifteenth
 century
 Purchased from G. D. Smith as part of the
 Robert Hoe library, 1911; HM 1100, fol. 4

Page 5, top to bottom:
 Ellesmere Psalter (see page 27)
 Apian, *Astronomicum Caesareum* (see page 106)
 The Spirit of 1928 [Advertisement for Stagg
 Commercial Photography Studio, Los Angeles],
 1928, hand-colored gelatin silverprint; PhotOV
 11427
 Elizabeth I, frontispiece of Saxton's *Atlas of
 England & Wales* (see page 149)

Contents

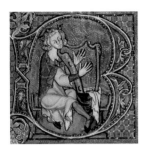

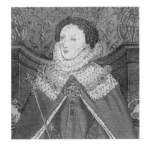

Mr. Huntington and His Library

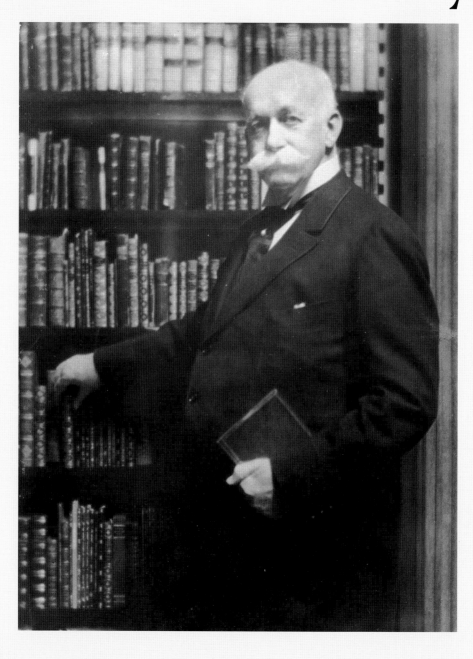

Near the end of Henry Huntington's life, someone asked him why he had never authorized a biography. He replied, "The Library will tell the story." What began as personal collecting on a modest scale blossomed into serious collecting in the antiquarian market during the first quarter of the twentieth century, and led to the formation of one of the world's major research centers for the study of Anglo-American culture, western Americana, and the history of science, medicine, and technology. Huntington's path from reader to collector to benefactor is a story of self-education, business success, indefatigable collecting, and ultimately, philanthropic responsibility.

Henry Edwards Huntington was born in Oneonta, New York, in 1850, the son of middle-class, mercantile parents. He was always an avid reader, though he had only a high school education; in later life he was often praised as a collector who knew and read his books. At age twenty, having tried his luck in his parents' hardware and dry goods business, he went to work for his uncle Collis P. Huntington, one of the owners of the Central Pacific and Southern Pacific railroads. Initially, he worked in a succession of mill companies in West Virginia, Kentucky, and Pennsylvania that made railroad ties for the westward-expanding railroads. To advance his fortune at one point, Huntington sold his first personal book collection to raise enough cash to buy out his business partner in one of these ventures. He went on to build a second reading library, composed mostly of sets of the writings of important contemporary authors, such as Dickens and Trollope. Many of these sets remain on display on the bookshelves in the large library room of the Huntington mansion.

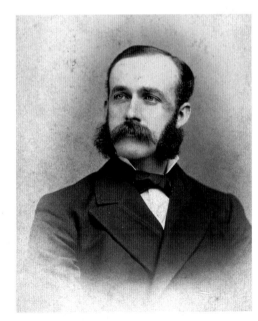

LEFT:
Henry E. Huntington
in his New York house,
ca. 1910

RIGHT:
Huntington,
ca. 1873

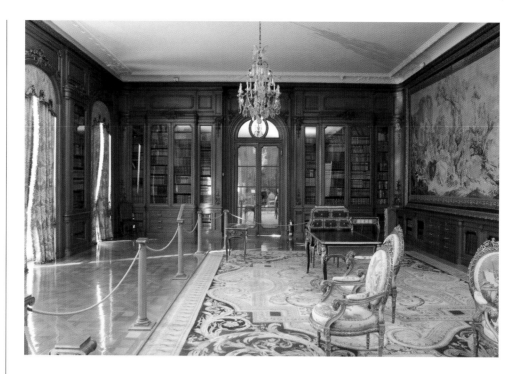

Huntington moved west in 1892. On his way to his post in San Francisco, he passed through Los Angeles, spending his first night in California on the grounds of what is now the Huntington Library, Art Collections, and Botanical Gardens— then the J. DeBarth Shorb ranch. Huntington was so taken with Southern California that he went there at every opportunity over the next eight years. When Collis died in 1900, Huntington withdrew from the management of the Southern Pacific and decided once and for all to relocate his western office to Los Angeles. (At the time, his principal residence was still in New York City.) In 1903, he bought the Shorb ranch and several adjacent properties totaling more than 800 acres. The core 207 acres remain today.

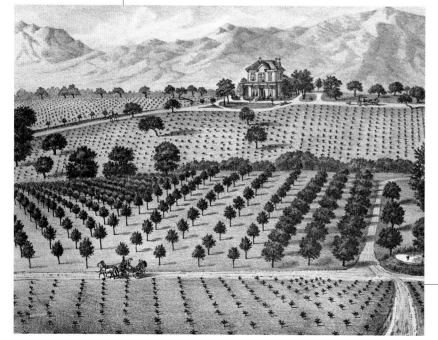

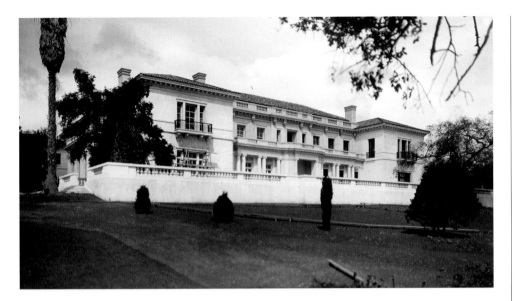

Huntington razed the original Shorb ranch house, an 1880s frame Victorian, and replaced it with the mansion that now houses the English and European art collections. Together, he and architect Myron Hunt planned, designed, and constructed the house, completing it in 1910. Hunt described Huntington's concept as "a residence around a library," for Huntington originally conceived the residence as one that would be capable of housing his library collections.

During this time, Huntington's book and manuscript collecting greatly expanded. He once defined the focus of his collecting as an interest in "the history of the English-speaking peoples." Having developed local rail transportation—the Pacific Electric Railway Company and its Red Car line—and having also developed land and utilities throughout the Los Angeles area, he retired in 1910 at the age of sixty to turn to his collecting interests. From then until his death in 1927, he was known as the world's greatest contemporary collector of rare books and manuscripts. In that seventeen-year period, he acquired more than 200 entire libraries, forming the core of the Library's research collection.

BELOW:
Political cartoon,
Los Angeles Evening News
(October 1905)

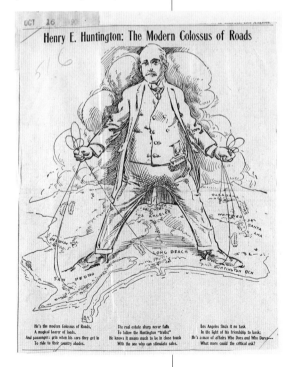

Huntington made an especially big splash on the antiquarian book-collecting scene when he purchased a copy of the Gutenberg Bible at the Robert Hoe sale in 1911, paying an unprecedented $50,000 for the two-volume folio printed on vellum or parchment. Of the forty-eight copies of the Gutenberg Bible known to survive, thirty-seven are printed on paper and eleven on vellum.

Huntington went on to dominate the Hoe sales that extended over the 1911 and 1912 auction seasons. He acquired the 1486 edition of Berners's *Book of Hawking, Hunting and Heraldry*; Caxton's first printed edition of Chaucer's *Canterbury Tales* (1477); the 1720 Dutch edition of Bayle's *Dictionnaire*; and several of the William Blake editions that would one day form the foundation of one of the most extensive Blake collections in America. Huntington's purchases accounted for more than a quarter of the entire Hoe sales. More importantly, they put Huntington in direct competition with the major collectors of his day, including J. Pierpont Morgan. After Morgan's death in 1913, Huntington dominated the sales for the rest of his own life.

BELOW:
"Whan that Aprill with hise shoures soote" opens the General Prologue to Chaucer's *Canterbury Tales*, shown here from the Ellesmere manuscript Purchased from the fourth Earl of Ellesmere, 1917; EL 26 C 9, fol. 1r

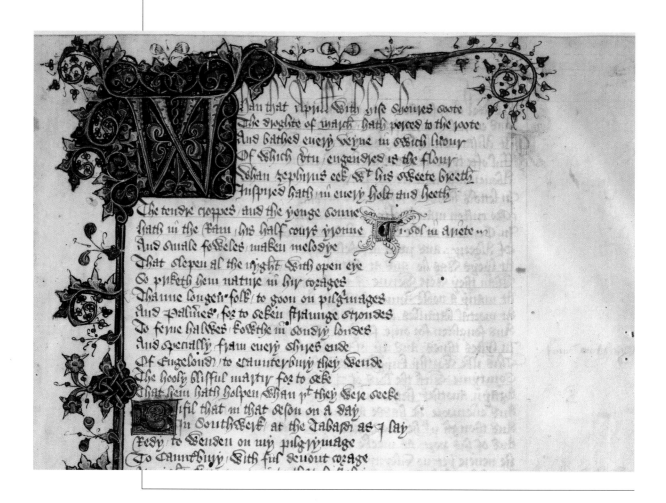

Beyond the auction houses, though, Huntington also became famous for acquiring whole collections en bloc. His first major purchase using this strategy actually occurred a year before the Hoe sale, when he bought the Elihu Dwight Church library. This eclectic collection included the fifteenth-century Simon Marmion Book of Hours, a copy of the first Latin edition of the 1493 Columbus letter (printed in Rome by Stephanus Plannck), a copy of the 1640 Bay Psalm Book (the first book printed in America), a copy of the John Eliot Indian Bible (the first Bible translated into a Native American language, Algonquin), a first edition of John Smith's *General Historie of Virginia* (1624), the only known surviving copy of *The Book of the Generall Lawes and Libertyes Concerning the Inhabitants of the Massachusets* (1648), and the manuscript of Benjamin Franklin's autobiography. The acquisition of the Church library also started Huntington on his Shakespeare collection, since it contained twelve copies of the folios and thirty-seven quartos. When New York antiquarian bookseller George D. Smith told him of a plan to divide the Church collection among various collectors, Huntington wrote back, "I won't join your syndicate, but if the collection can be had reasonably, I'll buy it myself." He and Smith negotiated a price of $750,000 with the Church estate, and the deed was done. At the time of the purchase, the Church collection was thought to be the greatest private collection extant, except perhaps for the Chatsworth library in England, part of which was also acquired by Huntington a few years later.

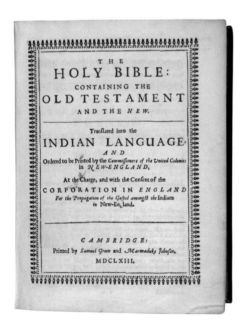 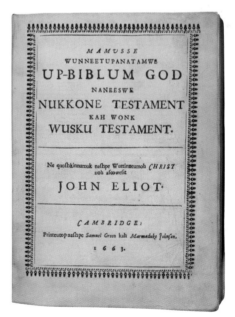

FAR LEFT:
John Eliot Indian
Bible
Title page in English
[Cambridge, Mass.:
printed by Samuel
Green and
Marmaduke Johnson,
1663]
Purchased as part
of the Church library,
1911; RB 18656

LEFT:
John Eliot Indian
Bible
Title page in
Algonquin
RB 18572

In 1912, Huntington bought the Beverly Chew library, which formed the basis of his collecting in English literature—including more than 2,000 sixteenth- and seventeenth-century imprints of English poetry. This was followed by the Henry Huth sale in 1913, which filled gaps in English prose and fiction. Then in 1914, Huntington purchased a large portion of the Duke of Devonshire's Chatsworth library for $750,000. Imbedded in the library was the John Philip Kemble collection of plays by Shakespeare and his contemporaries. Among these holdings were both the 1603 "bad" quarto and the 1604 "good" quarto of *Hamlet* (the Huntington is the only library to own both editions) and fifty-seven additional quartos and four folios. Additional dramatic holdings included almost 7,500 plays performed in London from 1660 to 1830. The Chatsworth acquisition also included twenty-five editions of imprints by William Caxton, the first printer in England.

In the same year, Huntington negotiated a purchase from the extensive William H. Lambert collection of Abraham Lincoln manuscripts, as well as a substantial portion of the collection of William Thackeray books, manuscripts, and letters that Lambert had originally acquired from the Thackeray family. In 1915, Huntington bought the library of Frederick Halsey, a New York lawyer and friend. This huge collection of 20,000 volumes included first editions of Shakespeare (more folio copies), Milton, Shelley, and Dickens on the British side, and Longfellow, Melville, and Poe on the American one.

In 1917, Huntington capitalized on the opportunity to acquire the Bridgewater library, which had been created in the seventeenth century by Sir Thomas Egerton (Baron Ellesmere and Viscount Brackley, 1540?–1617) and built up over several generations. The library comprised 4,400 printed books and more than 14,000 historical and literary manuscripts and letters. The most famous item—now known as the Ellesmere Chaucer—is a manuscript of the *Canterbury Tales*. The Bridgewater library also contained more Shakespeare folios and quartos, including one of only

two surviving quarto copies of *Titus Andronicus* (1600). From a research perspective, one of the most significant parts of the Bridgewater library is the set of plays amassed by John Larpent, who served as the official inspector of plays from 1778 to 1824. These are manuscript copies of plays that were annotated by their authors and submitted for approval under the Licensing Act of 1737; they comprise nearly every play performed in London over the course of Larpent's tenure. As with the Chatsworth library, the Bridgewater was originally offered for dispersal because of the death of the third Earl of Ellesmere and the estate taxes owed by the Egerton family. They had made arrangements for auction at Sotheby's, but once again, Huntington was able to step in ahead of the public sales through George Smith's agency and negotiate the en bloc purchase for $1 million.

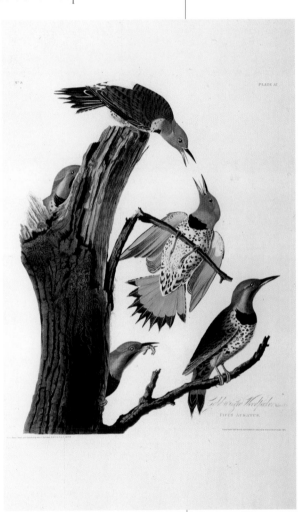

Another of Huntington's collector friends, William K. Bixby, decided to sell his library in 1917, but Huntington offered to buy it en bloc before Bixby put it up for auction. The library included a presentation copy of Shelley's "Queen Mab" to Mary Godwin; some of Charles Dickens's correspondence; and the manuscript of John Ruskin's *Seven Lamps of Architecture*, with sixteen of Ruskin's original accompanying drawings. American holdings in the Bixby library included the journals of Aaron Burr and of Major John André (the British agent involved in Benedict Arnold's treason plot), Thomas Jefferson's account book, and some of George Washington's correspondence. Huntington was so focused upon the British literary holdings and American historical manuscripts of Bixby's collection that he did not realize he had also managed to acquire a complete set of the double-elephant folios of Audubon's *Birds of America*.

Three great English archives came Huntington's way in the last four years of his life. In 1923, he purchased the Battle Abbey papers from the collection of Sir Thomas Phillipps (1792–1872). These documents, which include court rolls, family papers, and charters, served as the foundation for the Huntington's medieval British historical studies. Huntington also culled almost 800 fifteenth-century books from the Phillipps collection.

ABOVE:
John James Audubon
The Birds of America
"Gold-winged
Woodpecker"
Purchased as part of
the Bixby library, 1917;
RB 108212, Plate 37

Two years later, in 1925, Huntington acquired the Stowe House manuscripts and archive, which included papers of the Temple, Grenville, and Brydges families, named for the estate from which they were purchased. These family papers, dating from the twelfth century, form a complement to the Battle Abbey collections, since they also contain important court rolls, charters, and deeds, as well as account books, letters, and legal documents from the estate. The British National Trust sends a contingent of scholars from Stowe each year to research this archive for information regarding the restoration of the estate, its gardens, and its outbuildings and statuary.

One of Huntington's last great purchases was the Hastings-Huntingdon papers, comprising 50,000 documents that trace the history of the earls of Huntingdon from the twelfth to the eighteenth centuries. The collection includes contemporary letters concerning Sir Walter Raleigh's expeditions, documents about the colonization of America, and an agreement between the Marquis of Dorset and Sir Thomas More, Cardinal Wolsey, and Henry VIII.

These are but a few highlights of the more than 200 libraries that Huntington acquired. During his earlier years of intensive collecting, 1911 to 1920, Huntington assembled the newly acquired collections at his New York City residence at 57th Street and 5th Avenue (the present site of Tiffany's). From 1911 to 1914, he sent some 50,000 books to San Marino, but by 1915, after the Chatsworth, Lambert, and Halsey acquisitions, both houses were full. In 1916, he announced publicly that he was going to relocate his entire library to San Marino. He contacted Myron Hunt

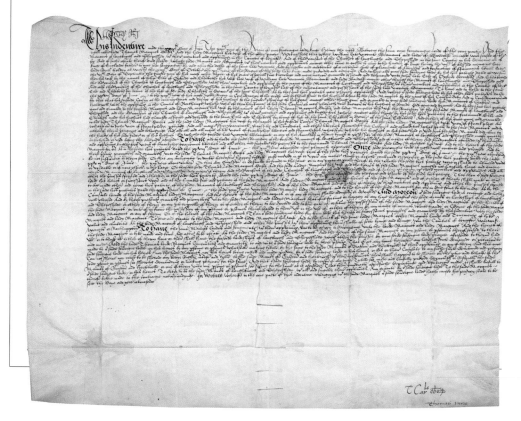

again, and they began to plan an additional building for the estate. By early 1919, they had agreed upon the design.

Construction of the library began in August 1919 and was completed by September 1920. Huntington had assembled a staff in New York a few years earlier, headed by George Watson Cole, the first Huntington librarian, and Leslie Bliss, a bibliographer who subsequently succeeded Cole as librarian. Huntington moved the Coles, Blisses, and eight other librarians' families from New York to San Marino, built houses for them, and set them to work unpacking, shelving, and cataloging the collections.

This was a bold move, considering the status of Los Angeles in 1920. To be sure, Huntington had played a key role in developing the city. He had created the light rail systems of the Pacific Electric Railway Company, established the commercial and residential properties adjacent to the rail rights of way, and built a utility infrastructure to power the burgeoning city. But many people in the eastern establishment and in academia criticized him for shipping such an extraordinary collection off to the "hinterlands."

We have to return to 1906 for a moment to understand the impetus for this move. Huntington not only wished to make Southern California his principal residence; he also placed great faith in the potential of the region to become a major commercial and cultural center. In turn, he wanted his collections to form the

foundation of a collection-based research and education institution. In his book *Henry Edwards Huntington: A Biography*, James Thorpe writes:

> The idea that these personal possessions should be made useful to the public in some permanent form was long in [Huntington's] mind... In 1906 he said, "I am going to give something to the public before I die." The principle was clear to him, and he frequently described himself... as "a trustee" whose responsibility for his books and manuscripts and art objects was "far greater than attaches to ownership of articles which there is some reason for regarding as purely personal."

In October 1906, Huntington related these ideas to George Ellery Hale, the famed astronomer and first director of the Carnegie Observatory at Mount Wilson, who was about to transform Throop Polytechnic into Throop College, the antecedent of the California Institute of Technology. Hale became one of the Library's first trustees when Huntington executed the indenture in 1919, founding the institution as a "public (research) library, art gallery, museum and park" dedicated to "the advancement of learning and the promotion of the public welfare." As he became more enthusiastic about Huntington's ideas for the research library in San Marino, Hale made very bold proposals for its design, suggesting that it be an exact replica of the Parthenon.

What captured Huntington's interest was Hale's concept that the Library would become an institution of "real international importance."

When the Library opened to scholars in 1925, approximately fifty scholars used the collections over the course of that year. Frederick Jackson Turner, the historian of the American frontier, was one of the first scholars to be in long-term residence, a tradition that continues today through the Huntington's extensive fellowship program in support of research—a program that has grown dramatically. To measure the progress of research, consider that by the 1946/47 academic year almost 600 scholars were registered to use the collections. Today, approximately

2,000 scholars make more than 21,000 visits annually.

Thanks to Huntington's vision, the Library remains a dynamic center for advanced research, with a growing collection and new facilities in the Munger Research Center to support scholarly activities. At the time of Huntington's death in 1927, it was estimated that he had amassed about 100,000 rare books, a million manuscripts, and 15,000 reference books. Twenty years later, in the 1946/47 annual report, Librarian Leslie Bliss stated that the Library had since added approximately 35,000 rare books, 68,000 manuscripts, and 100,000 reference books. The latter figures suggest how important it was to augment the rare collections with reference tools in order to turn a private collector's library into a collections-based research library for scholars.

Since Huntington's passing, the Library has approximately quadrupled its collections, with a total of 800,000 rare books and reference books, 4.5 million manuscripts, almost half a million photographs, and more than half a million prints, maps, and other ephemera. Principal areas of collecting remain printing history, history of science, British and American history and literature, and the history of California and the West.

One example of a recent acquisition, and perhaps the most significant purchase since Huntington's day, is the Sanford and Helen Berger collection of William Morris, the nineteenth-century British socialist who helped lead the English Arts and Crafts movement. This collection includes more than 2,200 printed books, the original papers of the archive of Morris & Co., 140 original Edward Burne-Jones drawings, cartoons of stained glass windows and an original window, and textiles and fabrics. The books include all of Morris's socialist pamphlets and a complete run of

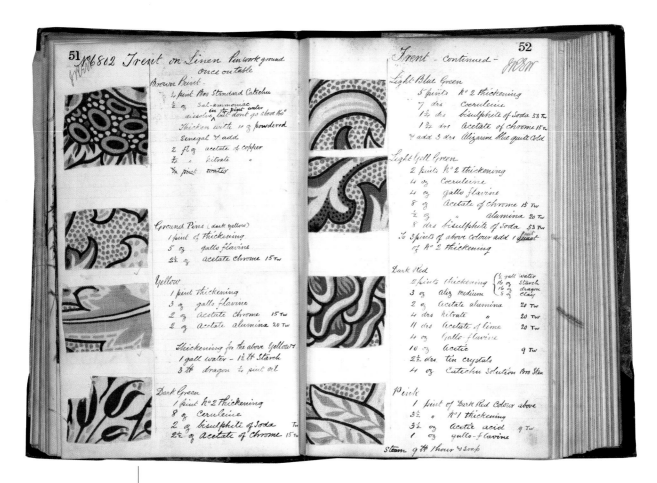

Kelmscott Press books. In the papers are original Morris type designs and trial proofs of pages for the Kelmscott books. There are also dye-books for the textile patterns, including formulas for the mixture of pigments and sample drawings and colorings for the textile patterns. These items complement materials that Huntington had purchased early on: Charles Morrough's collection of Kelmscott publications and more than 2,000 literary manuscripts, documents, and letters by Morris and members of the Pre-Raphaelite Brotherhood. The Berger acquisition makes the Library the leading center in America for the study of the English Arts and Crafts movement.

With the opening of the Munger Research Center in 2004, the Library embarks on the institution's second century with 90,000 square feet of space allocated for acquisitions, an enhanced reading room for the use of rare materials, three additional classrooms, twenty-two offices for long-term scholars, expanded conservation and photography laboratories, and a new suite of administrative offices. More than ever, the Library is poised to carry out Huntington's vision for a research center of national and international prominence.

A note on sources: almost all of the information in this introduction has been culled from previously published works about Henry Huntington's life and collections. For further reading in depth about these subjects, see:

Donald C. Dickinson. *Henry E. Huntington's Library of Libraries.* (San Marino: Huntington Library, 1995).

James Thorpe. *Henry Edwards Huntington: A Biography.* (Berkeley, Los Angeles, and London: University of California Press, 1994).

James Thorpe. *Henry Edwards Huntington: A Brief Biography.* (San Marino: Huntington Library, 1996).

BELOW:
Architect's rendering of the Munger Research Center

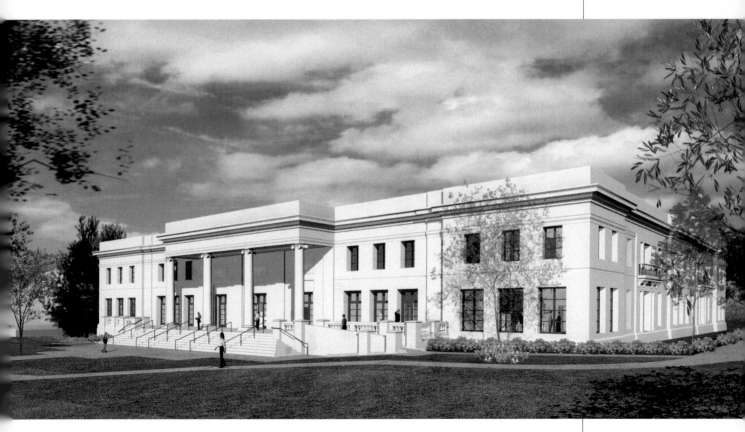

Manuscripts

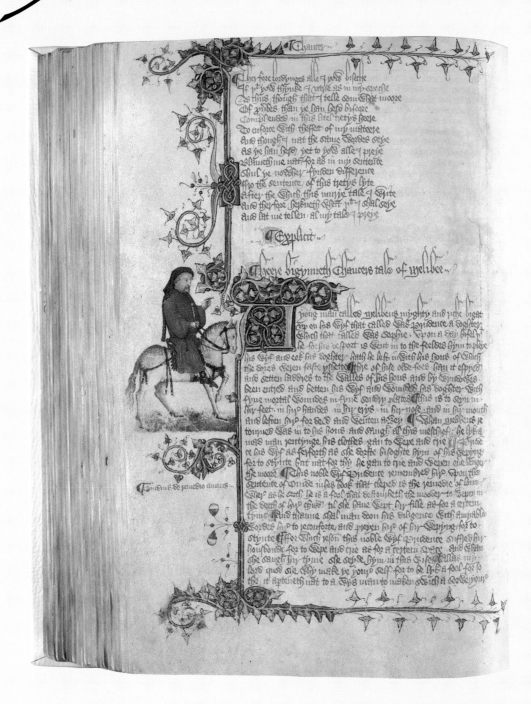

Medieval and Renaissance Manuscripts

The vigor and vibrancy of medieval intellectual, spiritual, and artistic life is illustrated in the Library's collection of more than 400 manuscript volumes created in England and Western Europe between the eleventh and sixteenth centuries. Huntington's first medieval acquisitions were beautifully illuminated Books of Hours, largely of continental European origin. With the acquisition of the Bridgewater library in 1917 came the famous Ellesmere Chaucer and a shift toward Middle English literature and legal, religious, and other scholarly treatises produced in England or for an English market during the Middle Ages and early Renaissance. Although the Library continued to acquire fine Continental manuscripts as well, both during and after Huntington's lifetime, the English volumes remain the principal focus of its medieval and Renaissance holdings. The Library now has the finest collection in the United States for the study of English medieval manuscripts.

Most medieval manuscripts deal with religious matters. Carefully designed, written on vellum or parchment (specially prepared animal skin, usually of calf or sheep), and often decorated with vivid colors and gold leaf (which, gleaming by candlelight, quite literally made an "illuminated" manuscript), these volumes were created in monastic scriptoria as works of piety, devotion, and discipline, and, later, in commercial scriptoria that sprang up in major European cities. The Huntington's collections include fifteen Latin Bibles, Gospels in Greek and Syriac, a fifteenth-century Wycliffite translation of the New Testament into Middle English, Biblical commentaries, sermons, biographies of saints, patristic writings, volumes of canon law, and a wide range of liturgical volumes such as the missals, antiphonals, and psalters used in church ceremonies and services.

The most recognizable volumes from this period are the Books of Hours that first caught Huntington's eye. Among the most popular and beautiful manuscripts of the late Middle Ages, they were intended for the private devotions of lay men and women and included Biblical and liturgical excerpts, prayers, and other texts for meditation, arranged for use during each of the eight canonical hours into which the Church divided each day. Such volumes traditionally began with calendars showing the major saints' days and religious festivals of the year (with the more important days entered in red or gold ink—hence our "red-letter days") and included jewel-like miniature paintings of scenes from the life of the Virgin Mary. Among the famous

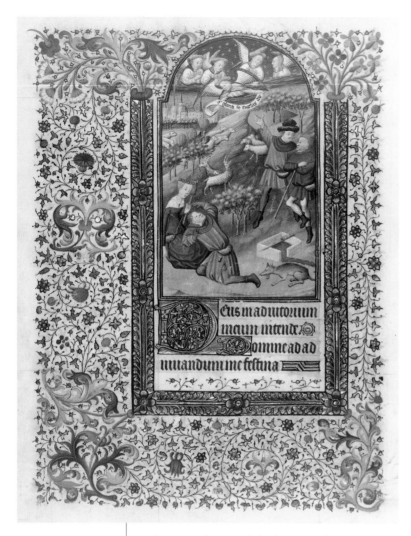

artists represented in the Library's medieval manuscripts are Simon Marmion, Simon Bening, Gerard David, Hermann Scheerre, and the anonymous illuminators of the Workshop of the Master of the Duke of Bedford.

While religious texts comprised the majority of manuscripts produced in the Middle Ages, an increasingly sophisticated English state also required books for government and administration. Accordingly, English statute books and legal treatises form a second major area of specialization within the Library's medieval holdings. Among the highlights of the medieval legal volumes are nine separate books and one parchment scroll of manuscript statutes, beginning with Magna Carta in 1215, and containing copies of the laws passed by the English Parliament. The earliest of these includes the unique surviving copy of a now lost and hitherto unknown preliminary draft of Magna Carta, headed "provisiones de Ronnemede." Other volumes contain texts by medieval legal scholars such as Bracton, Fortescue, and Littleton; treatises on Roman civil law and Norman French law; and registers of legal writs.

By Edward III's reign (1327–77), English was replacing French as the language of the royal court and aristocracy, while an expanding London merchant class found more time and means for education and literature. The resulting explosion of works written in Middle English is represented at the Huntington by fifty-nine volumes containing nearly 250 texts. This assortment of histories, chronicles, biographies, poems, plays, romances, epics, scientific treatises, medical and culinary recipes, prayers, homilies, meditations, and an early Wycliffite New Testament comprises the greatest collection of Middle English literature in manuscript in the United States.

The most important of all the Library's Middle English manuscripts is the famous "Ellesmere Chaucer." Compiled within five years of Chaucer's death in 1400, it is the earliest complete copy of this cornerstone of English literature. Produced in a luxurious, large-folio format on fine vellum and lavishly decorated with gold leaf and floral borders, it is also famous for its twenty-three beautifully realized miniature portraits of the pilgrims to Canterbury. Images of the "verray parfit gentil knyght," the poor Oxford scholar, the colorful Wife of Bath, the earthy Miller, their fellow travelers, and Chaucer himself present a rich visual cross section of medieval English life to complement this humorous, humane, and timeless poem. At Chaucer's death, the *Canterbury Tales* was an unfinished collection of individual stories, the "General Prologue," and some connecting links. Because no manuscripts of the work survive in Chaucer's own hand or from his lifetime, we rely on later copies to reconstruct the final form of the finished text. It was the unknown editor of the Ellesmere manuscript who first organized these disparate parts into the unified whole we read, study, and enjoy today.

Because Middle English texts frequently vary from copy to copy—not until the invention of printing could they become more standardized—modern scholars need to consult numerous manuscripts of the same work to determine the most authoritative reading. *Piers Plowman* by William Langland, for example, survives in three widely varying versions in more than fifty manuscripts, of which four (representing both the B Text and the C Text) are located at the Huntington. Also represented are textually important manuscripts of major authors of the Middle English canon, including John Gower, Thomas Hoccleve, John Lydgate, and Chaucer. By choosing to write in Middle English rather than French, these authors created a vigorous new vernacular literature for England, suitable for both elite and popular tastes.

While the secular literature and art of the ancient world had not disappeared altogether during the Middle Ages, they were studied with renewed interest in Italy during the fourteenth century. Chaucer himself had traveled to Italy as a young man and experienced first-hand the reawakening of interest in classical literature, language, philosophy, and art that characterized the Renaissance. Applied to contemporary society, these enthusiasms inspired literary, philosophical, and artistic creativity, which spread gradually north and west throughout Europe, reaching England in the sixteenth and early seventeenth centuries. The Library's Italian Renaissance manuscripts include handsome copies of Aristotle, Virgil, Cicero, Plutarch, Juvenal, Ovid, and many other classical writers.

THE GUNDULF BIBLE

The large format and elegantly spare Romanesque design of this vellum manuscript suggest the high status and importance of the Latin Vulgate Bible for medieval Christianity. The Gundulf Bible was written by a team of scribes, using a hierarchy of different scripts, with the first lines of the prologues and of each book of the Bible set out in red display lettering, called rubrication.

The page shown here is the opening of the Book of Genesis, "In Principio…" [In the Beginning…]. This handsome Bible in two volumes was given to Rochester Cathedral shortly after the Norman Conquest by its new bishop, the multi-talented Gundulf, an Anglo-Norman cleric, scholar, and architect who designed the Tower of London for William the Conqueror.

RIGHT:
"Book of Genesis"
The Gundulf Bible,
in Latin,
England or possibly
Normandy, late
eleventh century
Purchased from
A. S. W. Rosenbach,
1924;
HM 62, Vol. 1 fol. 2v

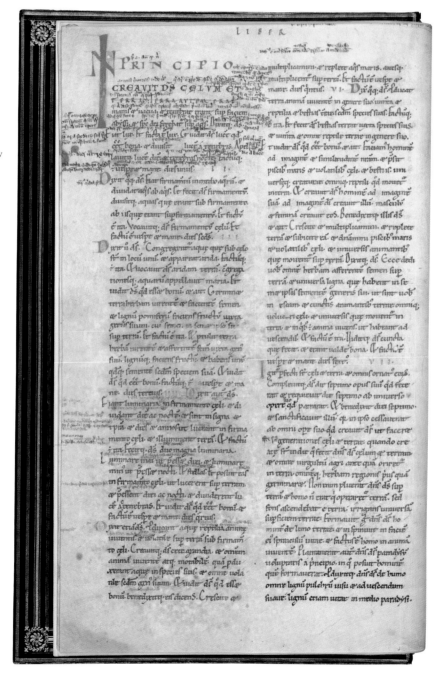

JACOBUS DE VORAGINE'S *LEGENDA AUREA*

This collection of saints' lives was composed in the mid-thirteenth century by Jacobus, or James, of Voragine, the Archbishop of Genoa. It remained a popular text throughout the late Middle Ages and into the dawn of printing. The vellum manuscript is a large and exceptionally beautiful copy, made during the author's lifetime and lavishly illuminated with 135 miniature paintings of saints (their martyrdoms depicted in delicately gory detail). The leaf shown here contains what is believed to be the earliest extant image of St. Patrick, whose staff is accidentally piercing the foot of the High King of Ireland at their first meeting at Tara. The scribe's tiny instruction to the miniaturist may be seen in the right margin next to the painting.

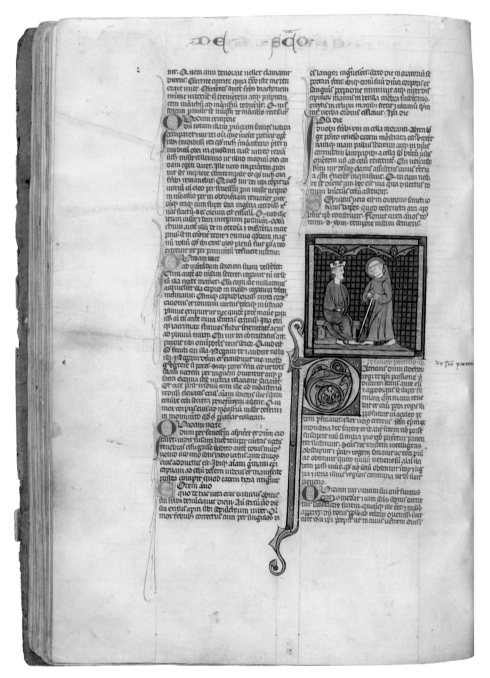

LEFT:
"St. Patrick"
Legenda aurea (Golden Legend), in Latin, composed by Jacobus de Voragine
France, late thirteenth century
Purchased from G. D. Smith, 1927; HM 3027, fol. 40v

THE TOWNELEY PLAYS

This unique surviving text of thirty-two short medieval "mystery" plays, dramatizing stories from the Bible, may have been a prompt copy for the trade guilds who preformed them on religious holidays in the town of Wakefield in Yorkshire. The Wakefield Cycle, one of the four great sets of English mystery plays, dealt with religious themes, but the use of Middle English rather than Latin and the robust humor of many of the plays attracted a wide audience from all levels of society; it is fundamental to the development of English secular drama. Seen here is the opening of the "Second Shepherds Play,"

which one scholar has described as "the finest example in English of a medieval mystery play;" without the present manuscript it would have been lost to history. The play begins "Lord what these wedders [i.e., weathers] ar cold…" and goes on to tell the broadly comic tale of two shepherds who steal a sheep and disguise it, wrapped in a cradle, as a newborn baby; underneath the rough humor is a sincerely pious foretelling of the birth of Jesus, the Lamb of God. This manuscript belonged to the Towneley family of Lancashire for almost three centuries, hence its popular name.

THE ELLESMERE PSALTER

This beautifully decorated and illuminated psalter (a collection of the Psalms, with a church calendar, prayers, and other liturgical texts) was created in England in the first half of the fourteenth century, perhaps for a lady of the Vernon family, whose arms appear twice elsewhere in the vellum manuscript. The page shown here depicts King David playing his harp in a handsome miniature painting on a gold background, with the coats of arms of England (three lions passant) and of Edward the Confessor. Despite the religious nature of the text, fanciful creatures inhabit the floral borders: various birds, a ladybug, a stag pursued by dogs, and a rabbit-in-hiding all testify to the whimsy, humor, and skill of an unknown medieval artist.

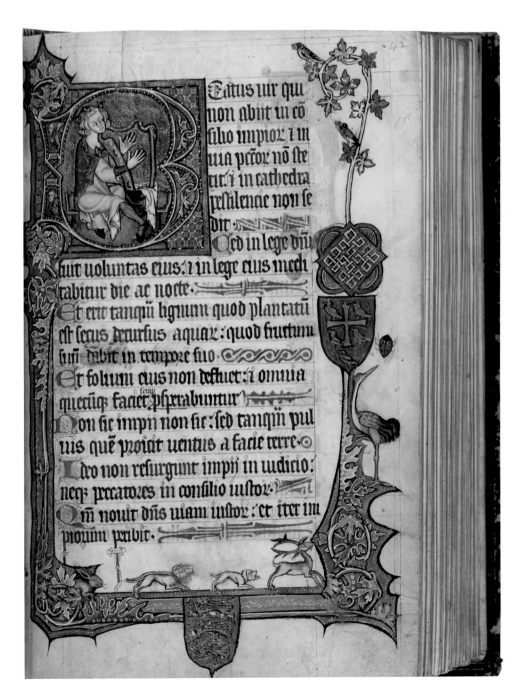

LEFT:
"King David with a Harp"
The Ellesmere Psalter, in Latin, England, first half of the fourteenth century
Purchased from the fourth Earl of Ellesmere, 1917; EL 9 H 17, fol. 42r

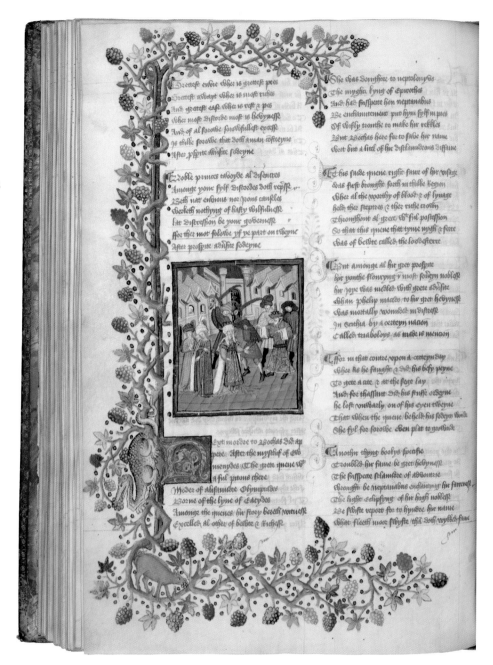

LYDGATE'S *FALL OF PRINCES*

A renewed interest in classical literature and history during the Renaissance provided a rich reservoir of themes for fifteenth-century European authors. This account of the fall from fortune of prominent men and women in classical history was translated by the English monk John Lydgate from a French version of Giovanni Boccaccio's popular *De casibus virorum illustrium*. The present manuscript was written in the middle of the fifteenth century and is one of the finest of approximately thirty surviving copies; only four of them are illustrated. It contains fifty-six illuminated miniature paintings, including the picture shown here of the death of Queen Olympias, mother of Alexander the Great.

VIRGIL'S *GEORGICS* AND *AENEID*

The Renaissance brought a revival of interest in the art, language, literature, and secular culture of the classical world, all of which find expression in this fine manuscript copy of two major works by Virgil. Shown here is the opening of his *Aeneid*, with the hero Aeneas in armor and mounted before the burning walls of Troy. The view of Troy itself is painted within an elaborate initial letter "A," beginning the famous first line of the epic "Arma virumque cano" (Of arms and the man I sing). This manuscript belonged to William Morris in the nineteenth century.

THE BERLAYMONT HOURS

The Library's most important Book of Hours contains seventeen miniature paintings by the renowned artist Simon Marmion, known to his contemporaries as the "Prince of Illuminators." Marmion was as famous for his manuscript miniatures as for his panel paintings, and his many works in both genres for the dukes of Burgundy and their circle helped make the Burgundian court a glittering artistic center of late medieval Europe. Shown here is the exquisitely detailed illustration of the "Adoration of the Magi;" the original painting measures less than 3 x 4 inches and is framed by a thin band of gold leaf. The present vellum manuscript was owned by the Berlaymont family in the sixteenth century; their coats of arms appear on two separate leaves. By the late nineteenth century, the manuscript had migrated to Prague and shortly thereafter was acquired for the U.S. collection of E. Dwight Church.

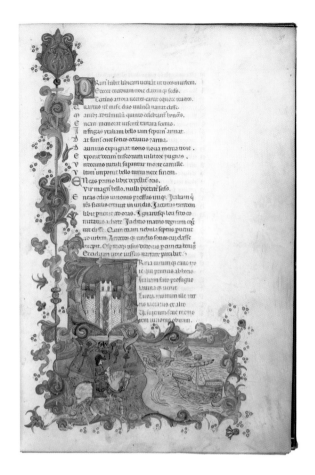

TOP RIGHT:
Virgil, *The Georgics* and *The Aeneid*, in Latin,
Italy, first half of the fifteenth century
Purchased through G. D. Smith, 1918;
HM 1036, fol. 38r

RIGHT:
"Adoration of the Magi"
Book of Hours, in Latin
Illuminated by Simon Marmion
France, second half of the fifteenth century
Purchased as part of the Church library, 1911;
HM 1173, fol. 50r

Elizabeth R

The Queenes Maiestie being right sory to understand that the order of comen prayer set forth by the comen consent of the realme, and by authoritie of the parliament in the first yeare of her raigne, wherin is nothing conteyned but the scriptures of god, and that which is consonant unto it, is now of late by some men despised and spoken against, both by open preachinge and writinge: And of some bold and busie meddling men, new and other rites, order, and forme of prayer, disputations and contentions, stirred up, and diffused, already risen, more like to insue: The cause of which disorders her Maiestie doth playnely understand to be the negligence of the Bisshops and other magystrates, who should cause the good lawes and ordinances of parliament made in this behalfe to be better executed, and not so dissembled and winked at, as hitherto (yt may appeare) that they have bene: For speedy remedie whereof, her Maiestie straightly requyreth and comaundeth all Archbisshops and Bisshops, and all Justices of assise, and every of them, and all majors, and officers of Cities and townes corporate, will their uttermost authoritie to put in execution the acts for the uniformitie of comen prayer, and the administracion of the sacraments, made in the first yeare of her gracious raigne, with all diligence and severitie: and for that some by dissembling with, one person or other, who doth neglect his duty or set to suffer the godly orders and rites set forth in the said booke: That if any person shall by publique preaching, writing or printing, comptrolle, dispise or dispraise the orders conteyned in the said booke, they shall apprehend him, and cause him to be imprisoned, untill he have answered to the law upon payne that the residue of them being present at any such preachinge and the like, do answere for their comtempt and negligence: whereby at the same tyme shall forbeare to comen order of comen prayer and receyve the sacraments of the same, according to the order in the said booke apoynted upon this and the like causes: All suche persons they shall requyre to present themselves and orderly answering as is prescribed in the said act, with more care and diligence then heretofore hath bene done. The great negligence which hath bene cause, whye suche disorders hath of late growen unmarked: and in some place increased and growen. And if any person shall eyther in pryvate houses or in publique places make assemblies and therin use other rites of comen prayer and administration of the sacraments then is prescribed in the said booke, or shall maynteine in their houses suche persons being notery suspected by bookes or preachinge to alter the litteracion of the said orders, they shall be furst present, punished not will otherwise according to the lawes of this realme, by payne of imprisonment in the said act. And bicause this matter doo principally appertaine to the care of persons ecclesiasticall, and to the ecclesiasticall gouernment, her Maiestie geveth a most speciall and earnest charge to all Archbisshops, Bisshops, Archdeacons, Deanes and all such as she doo ordinary jurisdiction in suche cause to have a vigilent eye, and care to the observation of the orders and rites in the said booke prescribed throughout their circuits, and to procede from tyme to tyme by ordinary ecclesiasticall jurisdiction as is graunted them in that behalfe with all celeritie and severitie against all persons who shall offend against any of the orders in the said booke prescribed, upon payne of her Maiesties displeasure for their negligence, and imputation from those disunitie and demerit, or other censures to follow according to their demerites. Geven at Grenewich the xx daye of Octobre 1573: In the xvth yeare of her Maiesties raigne.

God save the Queene.

British Historical Manuscripts

Scholars may study nine centuries of British history in the Library's collections of more than 80,000 letters and nearly half a million additional manuscript accounts, title deeds, legal records, diaries, journals, wills, and other rare documents dating from the Norman Conquest to the reign of Queen Victoria. The voluminous papers of seven major English aristocratic families, a complete monastic archive covering the 400-year life of Battle Abbey, the correspondence of prominent military, political, and social leaders of the sixteenth through nineteenth centuries, and many smaller collections and individual manuscripts form a solid mountain of evidence for original research in all aspects of British life and culture.

The surviving records of great landed estates (whether owned by a secular aristocracy or—until the Reformation—by the Church) constitute the primary documentation for the lives of all those who worked their farms, managed their properties, or provided goods and services. Title deeds, land grants, and financial accounts trace land ownership, land use, and individual wealth or poverty; manorial court records document the complex legal and social relations of everyday rural life at the local level; commissions, administrative inquisitions, appointments to office, and political correspondence illustrate the exercise of political power at every level. The Library's collections include more than 800 original court rolls (records, chiefly medieval, of court proceedings) for estates in numerous counties, as well as the medieval sections of some 13,000 title deeds and more than 250,000 accounts, receipts, and other financial documents.

Both central and local government during the English Renaissance are well illustrated in the papers of the Egerton family, barons Ellesmere and earls of Bridgewater. The founder of the family's fortunes, Sir Thomas Egerton, was the Crown's chief legal officer in Elizabeth I's later years, and Lord Chancellor under James I; he began, and his descendants continued, the famous Bridgewater library purchased by Huntington in 1917. Equally active in government, politics, and society were the Hastings family, earls of Huntingdon; their 50,000 manuscripts document the history of a great aristocratic dynasty from its medieval beginnings to the Victorian era.

Not all prominent English families of later years trace their origins to the medieval aristocracy. The Temples, for instance, who eventually built the magnificent country house and landscape gardens at Stowe in Buckinghamshire (the gardens are now a treasure of the National Trust), began as ambitious but small-scale landowners and sheep farmers in the mid-sixteenth century. They rose through ambition, hard work, and political savvy into the ranks of the gentry and lesser aristocracy, collected government offices, and made several prosperous marriages to merge with the Grenville family—subsequently dukes of Buckingham and Chandos in the nineteenth century—and with the Brydges dukes of Chandos, who had brought military profiteering and artistic patronage to a high point in the eighteenth century. The archives of all three lines, preserved at Stowe through more than one family bankruptcy by the time of World War I, comprised more than a third of a million manuscripts and were purchased by Huntington in 1925 to become the single largest collection of historic manuscripts in the Library.

By the eighteenth century, England's political stability at home, growing military and colonial power abroad, and increasing economic prosperity brought more time for the cultivation and enjoyment of what one recent historian has called the "Pleasures of the Imagination." The development of the fine arts and the appreciation for museums and galleries, music and theater, gardens and architecture, sociability and salons and assemblies may be seen in the diaries and journals of peers and politicians, diplomats and soldiers, amateur musicians, wives and daughters, children at school and young men on tour; in more than 300 wills of men and women, from dukes to carpenters; in household inventories and other records of material culture.

Yet for all its cultural accomplishments, the eighteenth century was far from peaceful, as England put down two Scottish rebellions, defended and then lost the American colonies, laid the foundations of a new global empire, and continued the intermittent but worldwide wars with France. The papers of British military and naval leaders form another major area of strength in the Library's research collections. Scholars study the papers (ca. 12,000 pieces) of the Campbell earls of Loudoun, who supported the Crown against Scottish Jacobite risings in 1715 and 1745, and later in the American colonies during the French and Indian Wars, or those of General James Abercromby (ca. 1,000 pieces), who succeeded Loudoun as commander in chief of the British forces in that latter conflict.

The history of war and politics from the British side may also be seen in the papers of the Townshend and Grenville families, aristocratic statesmen and politicians who held numerous offices at the center of power. In 1917, Huntington purchased a small, choice set of Townshend family papers concerning the British Cabinet and the American Revolution, including George III's bitter 1782 letter on American independence, written to Home Secretary Thomas Townshend (see page 36). Like the Townshends, the Grenville family of Stowe held numerous government and political offices in these years, providing two prime ministers, a chancellor of the Exchequer, a secretary of state, a foreign secretary, a Colonial secretary, two first lords of the Admiralty, and many diplomats, lords lieutenant, and Members of Parliament. The Library possesses more than 35,000 letters from their political, official, family, and business correspondence.

The depressions of the late nineteenth century, combined with the rising cost of income taxes and death duties, conspired to send many aristocratic assets to the auction block during and after World War I. Thus, Huntington's plans for a research institution coincided with an unparalleled opportunity to acquire rare manuscripts and books for the study of British history and culture. As Dr. John Pomfret, former Director of the Huntington, noted in 1969, "It is believed that the English archival material in the Library is more extensive and more important than that held by any other institution outside of England."

LETTERS PATENT OF EDWARD III

BELOW:
Edward III
(1312–1377)
License of Alienation
to Walter de Perle,
6 March 1377
Purchased as part of
the Hastings family
archive, 1927;
HAD 3641

Because lands owned by the medieval English church were exempt from certain feudal dues and obligations otherwise due to the Crown, royal permission was needed before anyone could give (or "alienate") property to a religious foundation. In this impressive vellum document of 1377, Edward III licenses Walter de Perle and others to transfer certain lands to the Prior and Convent of Christchurch in Hampshire. The most formal executive and administrative documents issued by medieval English rulers were in this form of royal "letters patent" (letters that were "open" for inspection), rather than closed and private, authenticated with the Great Seal of England. The seal shown here, the eighth version used during Edward III's long reign, depicts the king enthroned in majesty, as a source of justice and good government; on the reverse is an image of the king in armor, mounted on horseback, symbolizing his role as military and feudal overlord. The wax seal is remarkably intact, as are the original braided pink and green silk laces that affix it to the vellum letter. This document, along with many others concerning the relations between Crown, Church, and property in medieval England, was preserved among the family archives of the Hastings earls of Huntingdon.

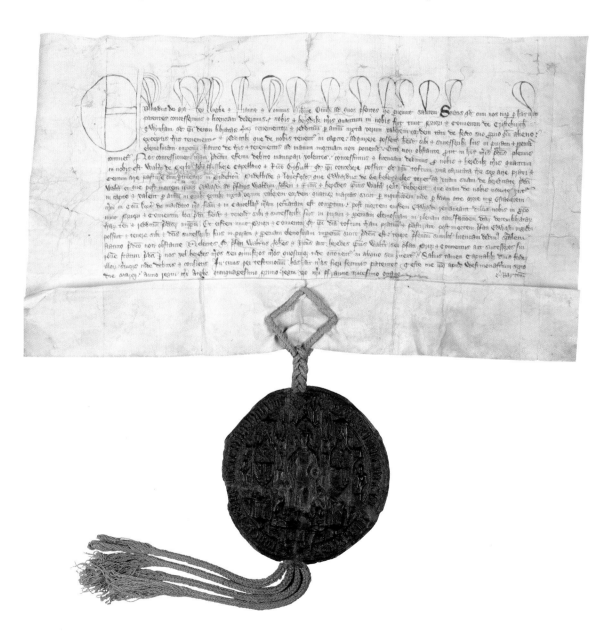

HOUSEHOLD RECORDS

Financial accounts, inventories, and other household records provide scholars with important evidence about the wealth, material culture, and lifestyles of ages past, supplementing more formal political, legal, and literary evidence. This vellum roll lists and evaluates the material possessions of Henry Hastings, third Earl of Huntingdon, in his principal home at Ashby de la Zouche, Leicestershire, at the time of his death in 1595. Among the contents of his luxuriously furnished "great Chamber," for example, are an "olde framed chayre covered wth olde clothe of gold and fringed wth whyte sylke," another of "crimson tufted velvett," two crimson embroidered cushions, many tapestry hangings, including one depicting "the Storie of the Romanes," and carpets from Flanders and Turkey, along with numerous tables, chairs, stools, cupboards, mattresses, featherbeds, bolsters, and two pairs of brass-topped Flemish andirons. The castle of Ashby de la Zouche was besieged and destroyed during the English Civil War, but these records bring back to life the world of its previous owners.

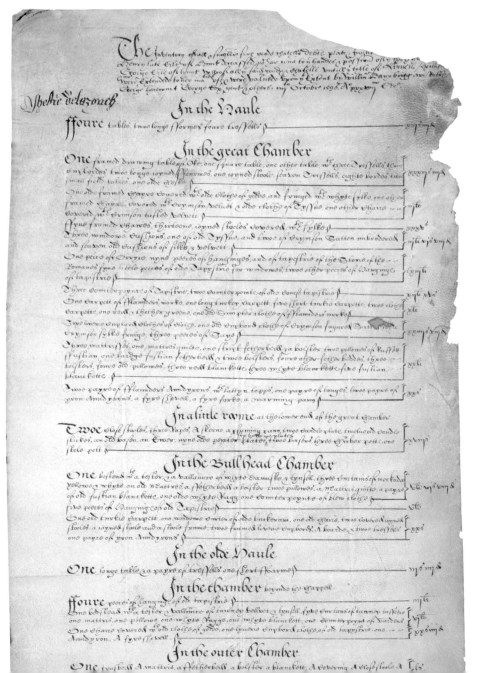

LEFT:
"Inventory of all goods, chattel, plate, and jewells belonging to Henry Hastings, late Earl of Huntingdon" Vellum manuscript roll, 4 October 1596 Purchased as part of the Hastings family archive, 1927; HA Inventories Box 1 (2a)

GEORGE III ON AMERICAN INDEPENDENCE

In this angry, bitter note to Home Secretary Thomas Townshend, George III (1738–1820) reluctantly authorizes the next stage in diplomatic negotiations at Paris for a peace between Britain and her former colonies at the conclusion of the American War of Independence. The King's unwillingness to accept defeat, and his estrangement from the policies of his own Parliament and ministers, may be seen in this resentful conclusion: "Parliament having to my astonishment come into the ideas of granting a seperation [sic] to North America, has disabled me from longer defending the just rights of this Kingdom. But I certainly disclaim thinking myself answerable for any evils that may arise from the adoption of this measure as necessity not conviction has made me subscribe to it." The King could not bring himself to write the word "independence": it may be seen, crossed out, beneath the word "seperation."

LOG OF THE *REVENGE* AT TRAFALGAR

First Lieutenant Lewis Hole kept this log on board the British ship HMS *Revenge* in the naval campaign that culminated in the Battle of Trafalgar during the Napoleonic wars. The seventy-four-gun *Revenge*, commanded by Captain Robert Moorsom, was sixth in line behind the leading *Royal Sovereign* when a column of Admiral Nelson's ships smashed through the French line of battle. The *Revenge* came under simultaneous fire from five enemy ships, took heavy damage, and lost twenty-eight of its crew, but survived to pick up French prisoners and sail into Gibraltar after the great British victory. Seen here next to the arrow, about one-quarter of the way down the page, is Lt. Hole's record of Nelson's immortal signal made to the British fleet, "England Expects that Every Man will do his Duty;" below that is the laconic "4 French ships and one three Decker on us at once." The volume remained in Hole's family and was unavailable to scholars until it was acquired in 2000. The Library's collection of ships' logs and journals spans four centuries, forming a substantial component of the institution's rich resources for studying the history of the British navy, navigation, exploration, and war at sea.

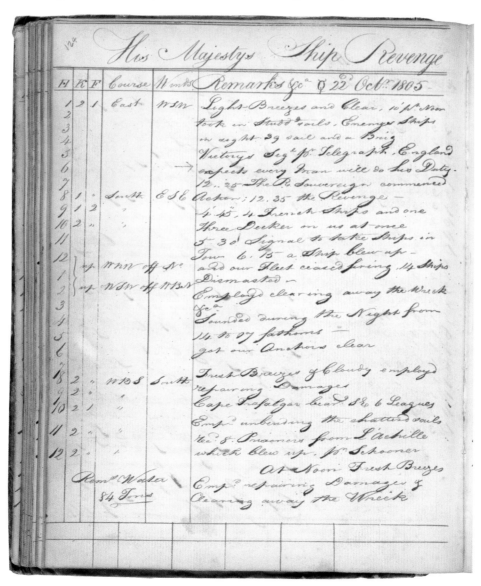

LEFT:
HMS *Revenge* logbook, 8 May to 25 December 1805 Purchased from H. P. Kraus, Inc., 2000; HM 60321

Twyford at the Bishop
of St Asaph's,
1771

Dear Son,

I have ever had a Pleasure in obtaining any little Anecdotes of my Ancestors. You may remember the Enquiries I made among the Remains of my Relations when you were with me in England; the Notes one of my Uncles who had the same kind of Curiosity, in collecting Family Anecdotes, once put into my Hands, furnish'd me with several Particulars relating to our Ancestors. From those Notes I learnt that the Family had liv'd in the same Village, Eton in Northamptonshire, for 300 Years, & how much longer he knew not, on a Freehold of about 30 Acres, aided by the Smith's Business which had continued in the Family till his Time, the eldest Son being always bred to that Business. — When I searched the Register, I found an Account of their Births, Marriages and Burials, from the year 1555 only, there being no Register kept in that Parish at any time preceding. By that Register I saw that I was the youngest Son of the youngest Son for 5 Generations back. My Grandfather Thomas, who was born in 1598, lived at Eton till he grew too old to follow Business longer, when he went to live with his Son John, a Dyer at Banbury in Oxfordshire, with whom my Father serv'd an Apprenticeship. There my grandfather died

and the Journey I took for that purpose. Now imagining it may be equally agreeable to you to know the Circumstances of my Life, many of which you are yet unacquainted with; and expecting a Weeks uninterrupted Leisure in my present Country Retirement, I sit down to write them for you. To which I have besides some other Inducements. Having emerg'd from the Poverty & Obscurity in which I was born & bred, to a State of Affluence & some Degree of Reputation in the World, the Means I made use of that conduced to that and having gone so far thro' Life with a considerable Share of Felicity, the conducing Means I made use of, which, with the Blessing of God, so well succeeded, my Posterity may like to know, as they may find some of them suitable to their own Situations, & therefore fit to be imitated. That Felicity, when I reflected on it, has induced me sometimes to say, that were it offer'd to my Choice, I should have no Objection to a Repetition of the same Life from its Beginning, only asking the Advantages Authors have in a second Edition to correct some Faults of the first. So would I change some sinister Accidents & Events of it for others more favourable, but tho' this were denyed, I should still accept the Offer. Since such a Repetition is not to be expected, the next Thing most like living one's Life over again seems to be a Recollection of that Life.

American Historical Manuscripts:
The Colonial Period through the Civil War

The Huntington's early American historical collections are important resources for the study of the Colonial and Revolutionary periods, the drafting of the Constitution, and the Civil War. Represented are explorers and settlers, soldiers and Puritan divines, Colonial gentry and slaveholders, delegates to the Continental Congresses and the Constitutional Convention, all the signers of the Declaration of Independence, U.S. presidents and their cabinets, abolitionists and suffragettes, Southern fire-eaters and fugitive slaves. Particularly striking is the largest collection of papers of the founders of the Republic to be found outside of the thirteen original states. There are hundreds of autograph letters written by George Washington and Thomas Jefferson, as well as the manuscript of Benjamin Franklin's autobiography. The Huntington can also claim the largest collection of autograph manuscripts of Abraham Lincoln west of Illinois, as well as hundreds of thousands of letters and diaries written both by well-known and obscure Americans of the Civil War era. The Library's American historical manuscripts are complemented by impressive rare book collections, including about one quarter of the early American imprints listed in *American Bibliography*, Charles Evans's massive compilation of titles printed in the colonies and early republic between 1639 and 1799.

Huntington's practice of swallowing other libraries whole sometimes brought benefits that were not immediately apparent. Robert Alonzo Brock was a nineteenth-century Richmond antiquarian who, by the time of his death in 1914, had amassed what has been described as "one of the largest and probably most valuable private collections of Virginiana ever assembled." The heart of the Brock collection was some 50,000 manuscripts dating from 1582 to 1914. Brock's heirs offered to sell the collection to the Commonwealth of Virginia. Virginia declined. In 1922, Huntington bought the entire collection. At the time, some history-minded Virginians deplored the transfer of so valuable a portion of their cultural legacy to far-off California. Yet eighty years later, officials at the Library of Virginia acknowledge that "researchers in general, and Virginians in particular, owe considerable thanks" to Huntington for keeping the collection intact. For it is certain that, were it not for Huntington's deep pockets, Brock's papers would have been irretrievably scattered.

The incomparable Church library laid the foundation of Huntington's American collections. Church had concentrated on printed books, but his collection did

FAR LEFT:
Benjamin Franklin
(1706–1790)
Autobiography,
autograph
manuscript
Purchased as part
of the Church library,
1911;
HM 9999, p. 1

contain some outstanding manuscripts as well. The greatest treasure was doubtless Franklin's autobiography. Other collections covering the Colonial and Revolutionary periods poured in after the Church acquisition in 1911. Some 500 autograph documents written by Thomas Jefferson include not only letters, but also architectural drawings and the fee book and case book from Jefferson's legal practice. Grenville Kane had collected nearly 200 autograph manuscripts of George Washington. Through his purchases from the Kane collection, Huntington brought in almost half of the Washington autographs found in the Library today. Thomas Addis Emmet was an indefatigable collector of Revolutionary documents. Much of his collection went to the New York Public Library; Huntington bought the rest. From across the Atlantic came the papers of General John Campbell (fourth Earl of Loudoun) and General James Abercromby, who were, successively, commanders in chief of all British and Colonial forces in America during the French and Indian War—the great imperial struggle for control of the continent. Assembled from a variety of sources, the Library's set of Continental Army orderly books from the American Revolution is an extensive one. There are also contemporary British orderly books, diaries, and journals from the War of Independence, notably the journal of Major John André, with a number of his handsome battle maps. Nathanael Greene, one of George Washington's ablest lieutenants, is represented by a large group of papers acquired from General Greene's grandson. A collection of Indian treaties from the seventeenth through nineteenth centuries features documents signed by Washington, Jefferson, Madison, and Monroe. There are groups of papers of Revolutionary statesmen like Robert Morris, Rufus King, and James McHenry.

The American Civil War held a prominent place in living memory when the Huntington Library was formed. Huntington was fifteen years old when news came that President Lincoln had been shot. It is no accident that the institution's Civil War collections, both manuscript and printed, are among the finest in existence. The manuscript collections are broad in scope and packed with exceptional rarities. Lincoln, as noted, is well represented in autograph manuscripts, as well as in the papers of his supporters and associates.

Around the turn of the twentieth century, a legendary group of Lincoln collectors, the so-called "Big Five," dominated the field. One of the collections, that of Judd Stewart, was acquired en bloc by Huntington. When another of the five collections, that of William H. Lambert, was auctioned off in 1914, Huntington captured the choicest lots.

Ward Hill Lamon, an Illinois lawyer and a friend of the president's during the White House years, was also a would-be Lincoln biographer. Lamon's papers, some 2,500 items, came to San Marino in 1914. Lamon had held onto many Lincoln autographs, but the real significance of the collection was its research value. For, in

addition to his own papers, Lamon had acquired the notes and transcripts compiled by the eccentric William Herndon, Lincoln's last law partner and one of his earliest and most important biographers.

Many collections illuminate the nation's political life during the Civil War era. That of Samuel L. M. Barlow, a prominent New York City financier and a Democratic Party chieftain, contains more than 30,000 documents. Barlow was a close friend of General George B. McClellan, vacillating commander of the Army of the Potomac and Lincoln's opponent in the presidential election of 1864. Republican Hiram Barney, represented by 8,300 manuscripts, held the lucrative patronage appointment as Collector of the Port of New York. The Huntington also holds a collection of 6,000 documents of Francis Lieber, a pioneering political scientist who served in the War Department during the 1860s. The military side of the Civil War is particularly well represented. The Library has autograph manuscripts of the many hundreds of men who held general's rank in the two opposing armies, from brigadiers commanding a few regiments to full generals directing the movements of armies numbering 100,000 or more soldiers. The Union is better represented than the Confederacy, but there are important groups of papers of Confederate States of America commanders like James E. B. Stuart, Robert E. Lee, Joseph E. Johnson, and Simon Bolivar Buckner. Union general Joseph Hooker's half-year tenure as commander in chief of the Army of the Potomac in 1863 is documented by some 4,000 of his military papers. Ulysses S. Grant and William T. Sherman are both represented by notable manuscripts.

Huntington bought en bloc two massive Civil War collections assembled by John Page Nicholson and James W. Eldridge. Both men had served as Union army officers in their youth, devoting their remaining years to gathering important documents. One of the more intriguing Civil War collections is that of Thomas Haines Dudley, numbering about 5,000 documents. From 1861 to 1872 Dudley was U.S. Consul at Liverpool, the port from which British ship builders launched the formidable Confederate raiders that swept Union commerce from the seas, deeply straining Anglo-American relations. Dudley ran a ring of spies and informants. He gave the U.S. State Department the evidence it needed to force London to back down and stop the flow of warships to the Confederacy. Other notable Civil War naval holdings include papers of admirals David D. Porter and David G. Farragut, as well as a fine group of papers of Navy Secretary Gideon Welles.

FIRST BRITISH COLONY IN AMERICA

The Virginia Company established the first permanent British colony in America at Jamestown in 1607. This "bill of adventure" records the investment of Henry, the fifth Earl of Huntingdon. He wagered £40 for a share in "Golde, Silver, and other metals or treasure, Pearles, Precious stones." But there was no gold. The company failed and its backers lost their money. Still, the colony hung on—and eventually prospered. The Huntington has three other examples of this excessively rare birth certificate of British North America.

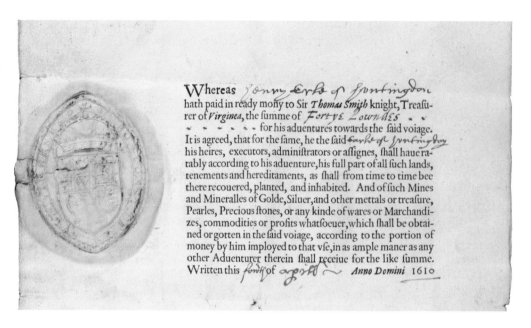

Whereas *Henry Erle of Huntingdon* hath paid in ready mony to Sir *Thomas Smith* knight, Treasurer of *Virginea*, the summe of *Fortye Poundes* — for his aduentures towards the said voiage. It is agreed, that for the same, he the said *Earle of Huntingdon* his heires, executors, administrators or assignes, shall haue ratably according to his aduenture, his full part of all such lands, tenements and hereditaments, as shall from time to time bee there recouered, planted, and inhabited. And of such Mines and Mineralles of Golde, Siluer, and other mettals or treasure, Pearles, Precious stones, or any kinde of wares or Marchandizes, commodities or profits whatsoeuer, which shall be obtained or gotten in the said voiage, according to the portion of money by him imployed to that vse, in as ample maner as any other Aduenturer therein shall receiue for the like summe. Written this *fowrth* of *aprill* — *Anno Domini* 1610

DIARY OF WILLIAM BYRD

The secret diary of William Byrd, the earliest and one of the most important of all Southern colonial diaries, was identified, transcribed, and published by Huntington curators in 1939. Byrd, proprietor of the elegant Westover plantation on the James River, was the consummate Colonial Virginia gentleman. The slaveholding aristocrat wrote the *History of the Dividing Line* and founded the city of Richmond and the Dismal Swamp Company. Most of his diary has disappeared, though two other volumes have turned up since the discovery of the Huntington copy.

Early Land Agreements

In this early land agreement, three Mohawks granted to New York Governor Thomas Dongan certain lands near Schenectady, New York. The tribesmen signed with pictographic signatures.

U.S. Constitution

The "Report of the Committee of Detail," the earliest version of the Constitution, was secretly printed for the delegates—with wide margins for note-taking—at about the halfway point in the debates. Only a handful of copies of the "Report" survive today; the Huntington Library holds two. Folio 6 of George Mason's copy bears the Virginia delegate's autograph notes.

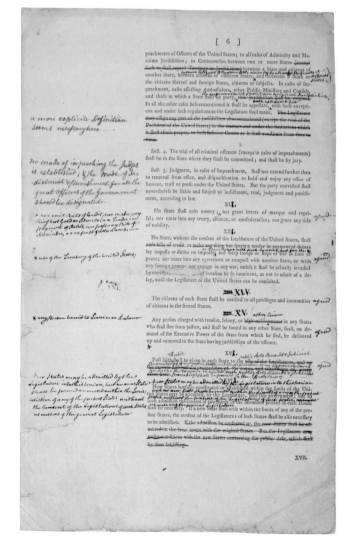

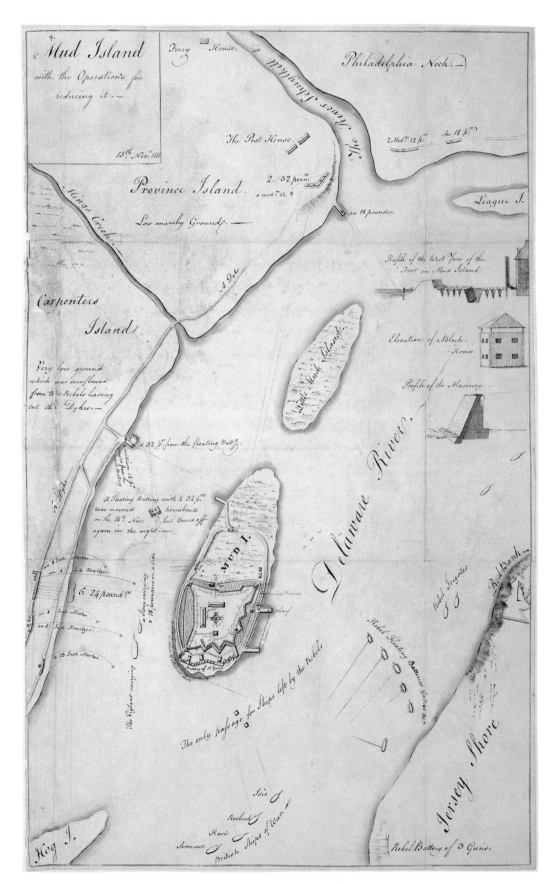

Mud Island

with the Operation's for

reducing it. —

15th Novr. 1777

Ferry House.

Philadelphia Neck.

The Pest House.

2. Med.rs 12 pdrs

An 18 pdr

Province Island.

2. 32 penns

a med.n 12. p.

an 18 pounder.

Manso Creek.

Low marshy Grounds. —

A Dike

Profile of the West Face of the
Fort in Mud Island

Carpenters

Island

Elevation of a Block-
House

Little Mud Island.

Profile of the Masonry. —

Very low ground
which was overflowed
from the Rebels having
cut the Dykes. —

A 32 p.r from the floating Batt.y

A Floating Battery with 2. 32 p.rs
was moored hereabouts
on the 15th Novr but towed off
again in the night. —

Delaware River.

MUD I.

6. 24 pounders

Battery of 18 Guns

Rebel Frigates

Redbank

Rebel Floating Battery Gallies &c.a

The only passage for Ships left by the Rebels

Isis

Roebuck

Pearl

Somerset

British Ships of Warr

Rebel Battery of 3 Guns.

Hog I.

Jersey Shore

JOHN ANDRÉ

The dashing British officer Major John André was hanged as a spy for his part in Benedict Arnold's treasonous plot in 1780. This handsome map is one of many included in his military journal for 1777–78. It depicts the British capture of an island that guarded the Delaware River passage to Philadelphia.

JOURNAL OF GEORGE WASHINGTON

Washington's account of his dangerous mission brought him fame on both sides of the Atlantic. The twenty-one-year-old Virginian had fought his way across hundreds of miles of frozen wilderness to deliver the British ultimatum demanding French withdrawal from the contested Ohio Valley. The Huntington owns one of eight recorded copies.

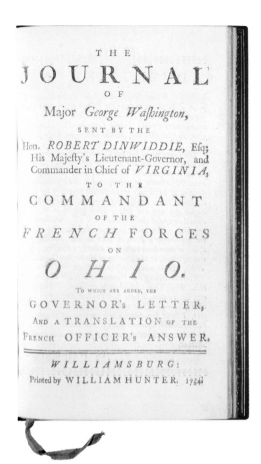

THE
JOURNAL
OF
Major *George Washington*,
SENT BY THE
Hon. *ROBERT DINWIDDIE*, Esq;
His Majesty's Lieutenant-Governor, and
Commander in Chief of *VIRGINIA*,
TO THE
COMMANDANT
OF THE
FRENCH FORCES
ON
OHIO.
TO WHICH ARE ADDED, THE
GOVERNOR's LETTER,
AND A TRANSLATION OF THE
FRENCH OFFICER's ANSWER.

WILLIAMSBURG:
Printed by WILLIAM HUNTER. 1754.

JEFFERSON THE ARCHITECT

"Architecture is my delight," Thomas Jefferson once wrote, "and putting up, and pulling down, one of my favorite amusements." The Library has hundreds of autograph manuscripts written by Thomas Jefferson, including about fifty architectural drawings.

August 5th 1789

My dear Sir;

I want to communicate two matters to Congress; the substance of Which is contained in the enclosed Papers.—The first requires to be decided upon be fore the proposed adjournment shall take place—but my motive for communicating the other at this time, is only to fix the atten tion, & to promote enquiry against the next meeting

Whether would an Oral or written communication be best?

If the first what mode is to be adop ted to effect it?

I would thank you, my good Sir, for a mending the enclosed address, if you have leizure, by adding to, or striking out such parts as you may think had better be a mended

I am most affectly
Yours

G Washington

WASHINGTON LETTER

A few months into his first term, the first president consulted the "father of the Constitution" on the workings of that untried document. The Constitution required that the president make foreign treaties with the "Advice and Consent of the Senate." But no one could say what form that advice should take. Here the president asked Madison, "Would an oral or written communication be best?" Washington's only attempt to negotiate a treaty with the Senate in person was a fiasco and has never been repeated by any of his presidential successors.

LEFT:
George Washington
Autograph letter to
James Madison,
5 August 1789
Purchased through
George D. Smith from
the Grenville Kane
collection, 1913;
HM 5100

LINCOLN ON EQUALITY

The spread of slavery into the western territories was the all-consuming issue when Abraham Lincoln challenged Stephen Douglas for an Illinois seat in the U.S. Senate. In the famous debates, Lincoln said that slavery was "a vast moral evil." Douglas countered that Lincoln was an abolitionist who favored racial equality. Not to refute such charges would be political suicide, since anti-black prejudice in Illinois was strong enough to assure the defeat of any candidate seen as a friend to African-Americans. In this position paper, Lincoln denied "all intention to bring about social and political equality between the white and black races." But he went on to affirm, "I think the negro is included in the word 'men' used in the Declaration of Independence—I believe the declaration that 'all men are created equal' is the great fundamental principle upon which our free institutions rest."

RIGHT
AND FAR RIGHT:
Abraham Lincoln
(1809–1865)
Autograph letter to
James N. Brown,
written in a small
pocket notebook,
18 October 1858
Purchased as part
of the Judd Stewart
collection, 1922;
HM 2144

Springfield, Oct. 18. 1858

Hon J. N. Brown

My dear Sir

I do not per ceive how I can express myself, more plainly, than I have done in the forego. ing extracts—In four of them I have expressly disclaimed all intention to bring about social and political equality between the white and black races, and, in all the rest,

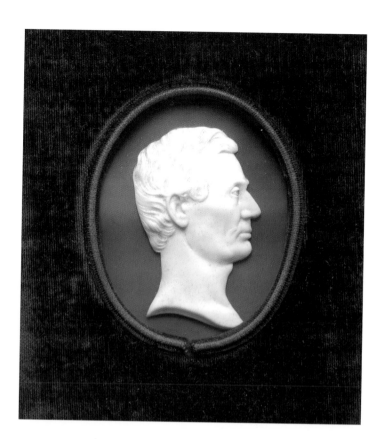

PORTRAIT OF LINCOLN

Chicago sculptor Leonard Volk created some of the best-known likenesses of Abraham Lincoln. Volk's work was based on a plaster life mask executed in March 1860, a few weeks before the Springfield lawyer unexpectedly won the Republican Party's presidential nomination. By the summer of 1860, Volk was seeking commissions for miniature profile portraits of the candidate. This is the only one that has ever turned up. Volk gave it to Dr. Charles Henry Ray, editor of the *Chicago Tribune* and an early Lincoln supporter.

LEFT:
Leonard Wells Volk
(1828–1895)
Abraham Lincoln, cameo on ivory, 1860, signed "L W Volk"
Gift of Mrs. James P. Andrews and Paul Ray, 1943 and 1954;
Papers of Charles Henry Ray

THE CSS SUMTER

During the Civil War, Confederate raiders like the *Sumter* swept the U.S. merchant marine fleet from the seas, ending American dominance of ocean-going commerce. Most Confederate warships were supplied by British shipbuilders. Anglo-American relations were deeply strained. At times the two great English-speaking powers seemed poised on the brink of a war that would have been catastrophic to both. Thomas Haines Dudley was U.S. Consul at Liverpool. His spies provided evidence of violations of British neutrality and gave the U.S. State Department the proof it needed to force London to stop the flow of warships to the Confederacy. Great Britain eventually paid millions of pounds to settle claims by American shipowners.

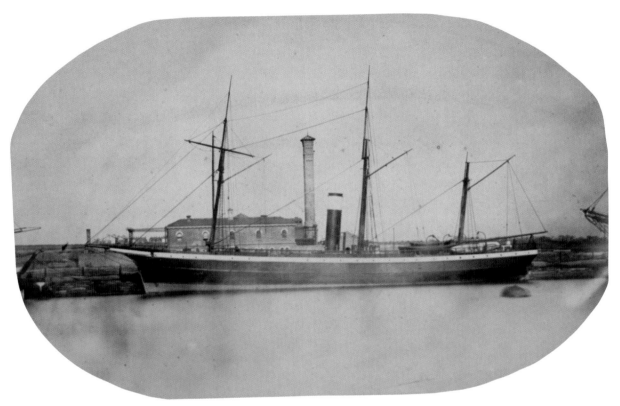

GENERAL SHERMAN'S MEMOIRS

General Sherman and his 60,000 veterans set out on their epic campaign in November 1864. On their way to the sea, Sherman's men would rip the heart out of Dixie. The day after leaving Atlanta, General Sherman talked to a slave, "an old, gray-haired man, of as fine a head as I ever saw. I asked him if he understood about the war, and its progress. He said he did, that he had been looking for the 'Angel of the Lord,' ever since he was knee high. And though we professed to be fighting for the Union, he supposed that Slavery was the Cause, and that our Success was to be his Freedom. I asked him if all the Negro Slaves comprehended this fact, and he said they surely did." *Memoirs of General William T. Sherman* was published in 1875. The Huntington holds the original manuscript in four tall volumes.

the main part of the town, and I asked
to be excused and rode on to a place
designated for camp at the crossing of
the ~~Yellow~~ River, to the ~~South~~ East of
the town. Here we made our Bivouac
and I walked up to a Plantation house
near by where were assembled many negros. Among
them ~~was~~ an old gray haired man,
of as fine a head as I ever saw —
I asked him if he understood, ably the war,
and its purpose. He said he did, that
he had been looking for the "Angel of the Lord,"
ever since he was knee high. And though
he professed to be fighting for the Union,
he supposed that Slavery was the Cause,
and that our success was, to be his freedom —
I asked him if all the negro slaves
comprehended this fact, and he said
they surely did. I then explained
to him that we wanted the slaves
to remain where they were, and not to load
us down, with useless mouths, that
would eat up the food needed for
our fighting men: that our success
was their assured freedom. that we
could recieve a few of their young
hearty men as pioneers, but if
they followed us in swarms of old

LEFT:
William T. Sherman
(1820–1891)
An incident on the
March to the Sea,
17 November 1864
From the autograph
manuscript of
Sherman's *Memoirs*;
HM 822

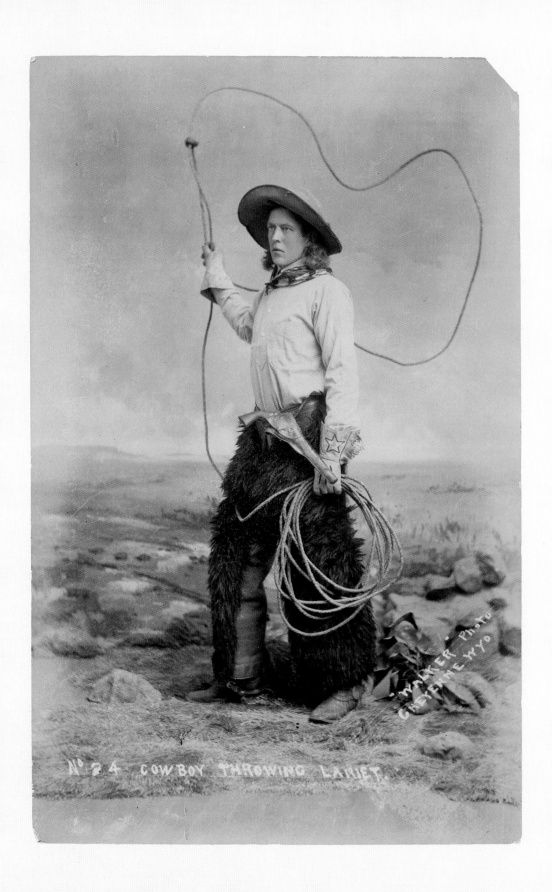

Nº 84 COWBOY THROWING LARIET.

Western American and California Manuscripts

Although the broad focus of Huntington's collecting was the history of Anglo-American civilization, his unwavering belief in the prospects of California led him to acquire materials documenting the history of the American West in general and the Golden State in particular. With his purchase of the Church collection of Americana in 1911 and the libraries of Augustin Macdonald (1916) and Henry R. Wagner (1922), Huntington brought together most of the significant imprints on the trans-Mississippi West, including the accounts of explorers, fur traders, missionaries, forty-niners, and overland emigrants. In succeeding decades, the Library has added many important nineteenth- and twentieth-century travel accounts, directories, guidebooks, newspapers, and state and local histories, especially for California, Oregon, Arizona, New Mexico, and Utah.

Beyond such rich resources of the printed word, the Huntington has also acquired hundreds of manuscript collections that portray the exploration and settlement of the North American West by Great Britain, France, and especially Spain in the sixteenth and seventeenth centuries and the steady movement of the United States into the trans-Mississippi West during the nineteenth century. Official records from representatives of various Spanish colonial administrations and the Catholic Church, for example, describe efforts to expand the boundaries of New Spain north from present-day Mexico and establish various civil and religious outposts in what would become Texas, New Mexico, and California. The records touch on nearly every aspect of colonial affairs, from suppressing the resistance of Indian peoples within colonial boundaries to forging peaceful relations—either through conciliation or coercion—with tribes beyond the frontiers of New Spain, and forestalling the intrusions of other colonial powers.

FAR LEFT:
"Cowboy Throwing Lariat"
Walker Photo Studio, Cheyenne, Wyoming, ca. 1910
Gift of Christine Myrick, 1950; Herbert Myrick collection, HM 49877

BELOW:
Diego de Vargas Zapata Lujan Ponce de Leon
"Autos de Guerra de la Reconquista del Reyno de Nuevo Mexico"
Manuscript, 17 December 1693– 4 January 1694
Purchased from Watson G. Ritch, 1923; William G. Ritch collection, RI 25

Valley of the Arkansas...

Diaries, journals, and letters of traders, fur trappers, and Protestant missionaries from the 1820s and 1830s depict encounters, both peaceful and hostile, with the region's many Indian peoples. Other documents describe the burgeoning trade routes that began to weave Mexican Alta California, British-ruled Oregon Territory, and the United States into a worldwide network of commerce. Accounts written by army officers, naturalists, and expeditionary artists from the 1830s through the 1850s record the federal government's progress in mapping western landscapes and surveying their natural and human resources. The papers of American, British, and Mexican merchants and landowners illuminate the last years of Mexican California before its annexation by the United States in 1846, whereas other collections comment from both the American and Mexican perspectives on the Mexican-American War (1846–48). Finally, as befits its enormous impact upon American

history, the California Gold Rush (1848–58) is represented in great detail. Scores of diaries and dozens of collections portray the journey to El Dorado by land or sea, as well as daily life for the thousands of gold seekers.

The rich holdings of western diaries and journals record journeys to many parts of the Far West, especially to the Mormon commonwealth of Utah. The collection of Mormon manuscripts and imprints, perhaps the finest outside Utah, follows the history of the Church of Jesus Christ of Latter-day Saints from its founding through its migration to the Salt Lake Valley and its efforts to colonize the Great Basin beginning in the 1840s. Joining letters and documents from Joseph Smith and Brigham Young are scores of diaries and reminiscences written by Mormon pioneers through most of the nineteenth century. Other prospective settlers, spilling across the Plains and Rockies or arriving in the port cities of the Pacific Coast, recounted their search for new opportunities throughout the West in hundreds of letters written to friends and loved ones.

In its exceptional collection of manuscript drawings, the Library possesses rich resources of images depicting the exploration, settlement, and development of the trans-Mississippi West. Artists both celebrated and anonymous are represented by their drawings of Native Americans, California missions, journeys by land and sea to Gold Rush California, the region's vast landscapes, and its burgeoning cities. In pen and ink, watercolors, and oils, they captured for posterity many events that others recorded with the written word.

The rising tide of emigration and settlement, especially after the Civil War, led to frequent, bloody conflicts with the indigenous inhabitants, as the United States strove to crush any resistance from western Indian tribes. Substantial collections of letters, diaries, orders, and reports from various officers serving in the field highlight the role played by the frontier army in westward expansion. The correspondence and documents of state and territorial officials from all parts of the West sum up the struggles and complexities encountered by the United States in governing these new domains.

Over time, the Huntington has acquired scores of collections that capture the many phases of the transformation of the West during the nineteenth and twentieth centuries, from the papers of express companies and mining engineers, railroad presidents and smelter owners, to those of itinerant prospectors, hardscrabble farmers, and well-heeled investors. Many of these collections focus on California's evolution into the economic colossus of the trans-Mississippi West, bolstered by its abundance of readily exploitable natural resources, its expanding industrial base, and its swelling cities. The collections also reflect the emergent diversity of the American West, as peoples from all over the world were drawn to the region in search of refuge or opportunity.

CALIFORNIA MISSIONS

Periodically, the Franciscan missionaries in Alta California furnished authorities in central New Spain with a formal accounting of the state of the missions under their care. This example from 1804 provides detailed figures for the native populations of each mission, enumerates the various forms of livestock, and assesses the production of grains and beans raised by the mission residents. Most of the details document the secular dimensions of the system, although the numbers of baptisms and marriages chart at least the outward success of the Franciscans in meeting their stated goal, the conversion and acculturation of the province's indigenous peoples.

Provincia de Californias. = Viva Jesus. Misiones de la Nueva California.

Noticia de las Misiones que ocupan los Religiosos de N. P. S. Fran.co Misioneros Apostolicos del Colegio de Propaganda fide, de S.n Fernando de Mexico en dha. Provincia. Sus progresos en los años 801. y 802. numero de los Misioneros: Sinodo que gozan, y total de Almas con dist.on de Sexos.

Misiones	Ministros	Sinodos			Indios			Españoles y gentes de otras clases		
		De Real Hazienda	De obra pia	Total de Sinodos	Hombres	Mugeres	Total	Hombres	Mugeres	Total de Almas
San Diego	2		800	800	737	822	1559			
San Luis Rey de Francia	2		800	800	256	276	532			
San Juan Capistrano	2		800	800	502	511	1013			
San Gabriel	2		800	800	317	297	614			
San Fernando	2		800	800	426	502	928			
San Buenaventura	2		800	800	521	572	1093			
Santa Barbara	2		800	800	457	571	1028			
Purisima Concepción	2		800	800	374	325	699			
San Luis Obispo	2		800	800	309	305	614			
San Miguel	2		800	800	568	484	1052			
San Antonio de Padua	2		800	800	296	267	563			
Nuestra Sra. de la Soledad	2		800	800	376	312	688			
San Carlos	2		800	800	530	428	958			
San Juan Bauptista	2		800	800	238	199	437			
Santa Cruz	2		800	800	736	555	1291			
Santa Clara	2		800	800	327	295	622			
San Jose	2		800	800	433	381	814			
N.ro P. S. Francisco	2		800	800						
Totales en 1802	18. 36		14.400	14.400	7945	7617	15562			
Existen en 1801	18. 36		14.400	14.400	7065	6603	13668			
Diferencia					0880	1014	1894			

Por la demostracion antecedente, se acredita que hubo de aumento en los Indios 1894. No hai Vecinos de otras clases en estas Misiones, solo existen en ellas las familias de la Tropa que las guarnece, y en algunas un Mayordomo.

En los dos años se verificaron 1328. Matrimonios de Indios; se bautizaron 4728. y murieron 2881. Asimismo en los Españoles, y gente de otras clases hubo 35. matrimonios, se bautizaron 185. y murieron 82.

En el total de Ministros, como deducido de dos en cada una de las 18. Misiones, se demuestra ser 36. Por tanto solo advierto, que a mas

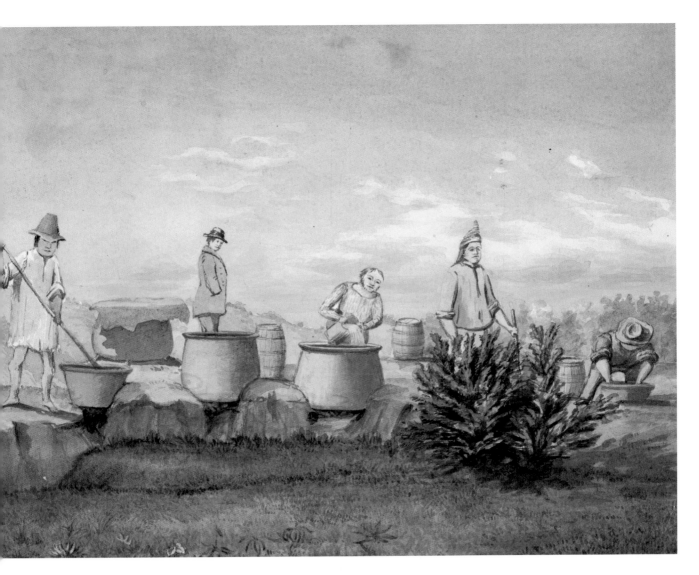

Rancho Era

In this watercolor, itinerant draftsman and surveyor William Hutton depicted an essential part of Mexican California's flourishing cattle industry. The Indian laborers "try" or melt down the fat of the cattle in cauldrons over open fires to produce the substance known as tallow, which was used in products such as candles or soap. The trade in cattle hides and tallow between California rancheros and Anglo-American merchants tied the isolated Mexican province into a worldwide commercial network.

ABOVE:
William Rich Hutton
"Trying Out Tallow, Monterey," ca. 1848
Pencil and watercolor drawing
Purchased from Mary Hutton, 1939; William Hutton collection, HM 43214 #61

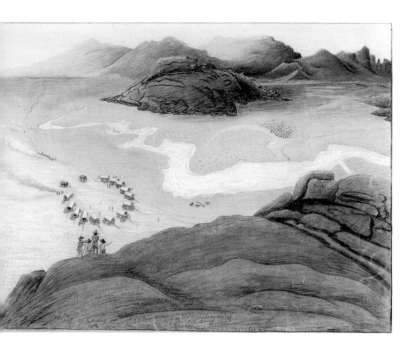

OVERLAND TRAIL

As they wound their way across the trans-Mississippi West toward California or Oregon, overland emigrants encountered various natural landmarks that denoted their progress. Independence Rock in present-day Wyoming attracted much attention because it had become a tradition for overlanders to inscribe their names on its surface. Bruff, a '49er bound for Gold Rush California, portrayed this vast migration in the 264 drawings he produced to illustrate his manuscript account of the odyssey.

Year after year, as the overland emigrants bound for the Far West set out on their great voyage, they encountered difficulties and perils far outside any previous experience. Harriet Ward, writing about her family's trip in the summer of 1853, described one thoroughly miserable night near the Platte River early in their travels: "Soon after we retired the wind commenced blowing a perfect gale & the heavens were overspread with a constant sheet of liquid fire . . . we soon found that our united strength would fail to hold our tent down & away it went . . . the storm was raging with relentless fury."

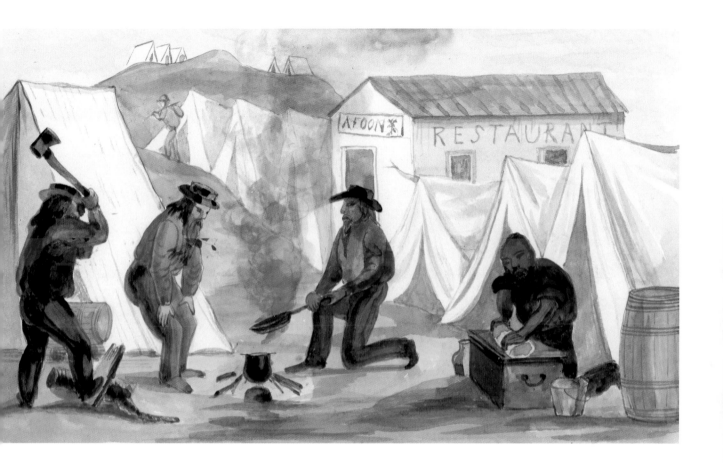

GOLD RUSH

In the early months of the California Gold Rush, the population of San Francisco expanded so rapidly that builders could not keep pace with the demand for shelter. Revere, an officer in the U.S. Navy and the grandson of Paul Revere, witnessed many new arrivals settling for temporary quarters under canvas, giving the city the appearance of a great "Camp Meeting," as one observer wrote. Revere's evocative illustration also captures the remarkable ethnic and racial diversity born of the global fever for gold.

ABOVE:
Joseph Warren Revere
"Street in San Francisco"
Watercolor drawing from his manuscript autobiography, 1849
Gift of Henry F. Allen, 1986;
HM 56913

CHINESE IMMIGRANTS

Especially during the early years of the California Gold Rush, most Euro-American argonauts scorned low-paying, menial jobs, so employers sought out new sources of labor. Jacob Leese, on a trading voyage to Hong Kong in 1849, recruited a small number of Chinese workers to fill certain trades. Within four years, Chinese emigrants by the thousands would be arriving in search of what they described as the "Gold Mountain." Although initially drawn to California in the 1850s by the lure of gold, Chinese immigrants thereafter found employment in many sectors of the state's developing economy. By the 1870s, Chinese settlement in California's inland valleys had grown significantly as agriculture took hold there. In the town of Newman, located in the northern reaches of the San Joaquin Valley, the Ju Jog family, for example, ran a laundry service next to the local saloon and lived amicably among the mainly Caucasian population. If some of their fellow Californians appreciated the immigrants' energy and determination, many found the Chinese way of life disturbingly alien and resented Chinese workers as potential competitors. Despite the increasingly vehement agitation against them, however, the Chinese by 1880 had become permanently woven into the fabric of an increasingly diverse California.

ABOVE:
Jacob P. Leese
Labor contract with
Ai, Chinaman
Hong Kong,
28 July 1849
Purchased from
Holmes Book
Company, 1922;
Mariano Vallejo
collection, VA 160

RIGHT:
Photograph of the Ju
Jog family, ca. 1890
Gift of the Latta
Family Trust, 1987;
Frank Latta
collection, Box 4
(1A), 11 (5c) of the
Skyfarming subseries

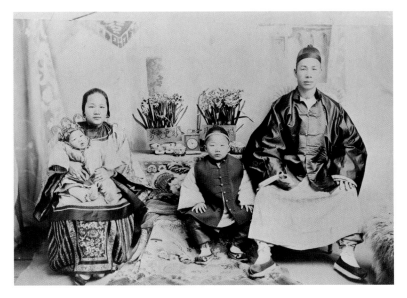

NATIVE AMERICANS

By the end of the nineteenth century, many of California's Indian communities had been driven to near extinction because of the relentless hostility of many Euro-American residents of the state and the unceasing pressure of their civilization upon Indian ways of life. As California's Indian peoples struggled to survive, continued pressure from anthropologists, journalists, and social reformers inspired more sympathetic appraisals of California's first human inhabitants. Professional scientists and enthusiastic amateurs began to capture the material culture and folkways of tribal communities and individuals such as Sinel of the Tache Yokuts. Seen here in his ceremonial costume—a handmade eagle-down skirt, sparrow-hawk feather ornaments, and head-dress of raven feathers decorated with eagle down—Sinel represented a world aligned with California's flora, fauna, and landscapes.

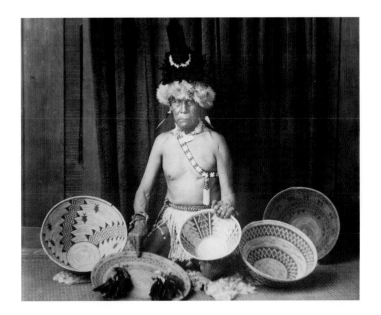

JAPANESE RELOCATION CAMPS

Following the Japanese attack upon American military installations in the Hawaiian Islands on December 7, 1941, wartime paranoia about potential "disloyalty" compounded the hostility toward Americans of Japanese ancestry that had pervaded the Far West for decades. As a result, in early 1942 the federal government forcibly evacuated more than 110,000 Japanese residents of Washington, Oregon, and California (over seventy percent of them American citizens) to ten relocation camps established in some of the most desolate spaces of the interior West. Incarcerated in these camps for as long as three years, many of the internees found opportunities for diversion, self-expression, and solace in different art forms. Painter Gus Nakagawa, capturing the effects of one of the howling desert winds known ironically as a "Poston zephyr," reminds the viewer of the inextinguishable spark of human creativity, even when confronted by the bleakest of circumstances.

To Build a Fire (alone......but)

He travels the fastest who travels ~~alone~~ not
after the frost has ~~dropped~~ dropped below
zero fifty degrees or more. ~~Rand~~ Yukon Code.

Day had just broken,
cold and gray — in-
finitely cold and gray —
when ~~the man~~ turned
aside from the main
Yukon trail and climbed
the high earth-banks,
where a dim
and little-traveled trail
led eastward through the
fat spruce ~~timbers~~
timber-land. ~~It~~
~~eastward~~. It was a
steep bank, and he
paused for breath
at the ~~top~~ top, excusing
the act to himself by
looking at ~~the~~ his watch.
It was nine o'clock.
There was no sun nor
hint of sun, though there

British and American Literary Manuscripts

The Library possesses one of the world's landmark collections of British and American literary manuscripts dating from the Renaissance to the present. These extensive holdings are especially strong in material relating to the eighteenth century in Britain, Victorian literature and the Pre-Raphaelites, American literature in the second half of the nineteenth century, drama and theater covering some 400 years, and archives for distinguished twentieth-century authors.

As has been mentioned, Huntington acquired books and manuscripts in groups—en bloc—and these groups were often very large indeed. For example, his 1917 purchase of the massive Bridgewater library brought many literary manuscripts from the Renaissance and Tudor-Stuart periods, including poems on Inigo Jones by Ben Jonson, poems by John Donne and Katherine Philips, and Thomas Middleton's *Game at Chesse*. A manuscript volume of John Marston's *Masque in Honour of Alice Countess of Derby* also contains tipped-in leaves that are "discovered" every few decades by a researcher who attributes their authorship to Shakespeare.

British drama from the mid-eighteenth through the early nineteenth centuries is richly represented by the Larpent collection of plays, consisting of scripts submitted for licensing to John Larpent, examiner of plays from 1778 to 1824. The resulting collection of 2,500 plays, most of them manuscripts in the hand of a copyist, with a few bearing autograph authorial revisions, forms a rich archive for the study of eighteenth- and nineteenth-century British drama. Both earlier and later materials are well represented in extensive holdings in drama. Starting with the medieval Towneley and Chester plays, and encompassing Renaissance and Tudor-Stuart drama, the collections also contain scores of letters from actors and theater managers.

For twentieth-century drama, there are archives for playwright Zoë Akins, who won the Pulitzer Prize for her adaptation of Edith Wharton's *The Old Maid*, and screenwriter Sonya Levien, whose Oscar statuette—won for her *Interrupted Melody* script—lends a bit of glamour to the manuscript stacks. These two collections offer lively glimpses of the film and drama scenes in New York and Hollywood from the 1930s to the 1950s.

Los Angeles drama is also represented by production files from the Mark Taper Forum and well over 1,200 scripts, many in multiple drafts. The Library holds the archives of playwrights such as Sheri Bailey, who writes about being a young African-American girl in the south; Velina Hasu Houston, whose plays, including *Kokoro*, explore cultural encounters and her own heritage as a Japanese-African-

American; and Wakako Yamauchi, whose play *12-1-A* is based on her high school years in the Poston Relocation Center in Arizona.

In 1913, Huntington purchased a collection of literary autographs owned by John Quinn; these consisted of correspondence and literary drafts by such nineteenth-century authors as Thomas Hardy, George Gissing, George Bernard Shaw, and George Meredith. The Quinn acquisition also encompassed a significant number of items by members of the Pre-Raphaelite Brotherhood and their associates, such as Dante Gabriel Rossetti, Christina Rossetti, William Michael Rossetti, Algernon Charles Swinburne, and William Morris.

Over the years, Huntington and, later, the Library curators, added much more material to the Pre-Raphaelite holdings, with letters (many containing original drawings) and manuscripts by artists such as Edward Burne-Jones, John Everett Millais, William Holman Hunt, and John Ruskin. Highly important William Morris manuscripts have been acquired over the years, culminating in the Huntington's 1999 purchase of Sanford and Helen Berger's spectacular Morris collection. As a result of the Huntington's collecting depth, the Library now ranks as one of the top institutions in the world for Morris, Pre-Raphaelites, and the Arts and Crafts movement.

In 1918, Huntington purchased the exceptionally rich William K. Bixby collection of manuscripts, which included three volumes of Shelley's notebooks, seven magnificent partial drafts of Henry David Thoreau's *Walden* and items by Charles Dickens, Robert Burns, Rudyard Kipling, John Greenleaf Whittier, and Bret Harte. Sizable series of autograph letters represented writers such as Samuel Taylor Coleridge, William Wordsworth, Mary Shelley, Charles Lamb, William Makepeace Thackeray, Dorothy Jordan, Ralph Waldo Emerson, Nathaniel Hawthorne, and Samuel Clemens.

The Bixby collection also included John Ruskin's *Seven Lamps of Architecture,* with a separate volume of related drawings. Ruskin wrote extensively about art and served as a mentor to the Pre-Raphaelite artists. His work deals with the leading principles of architecture and is illustrated with engravings of his original drawings; as a whole, it promotes Gothic as the noblest style of architecture. The "Seven Lamps" in question are Sacrifice, Truth, Power, Beauty, Life, Memory, and Obedience.

Here, too, are found the papers of Elizabeth Robinson

Montagu, a socially prominent author and intellectual. To her literary salons came such figures as Hannah More, Horace Walpole, Samuel Johnson, David Garrick, and Sir Joshua Reynolds. Among Montagu's acquaintances was her sometime social rival Hester Thrale Piozzi, whose diary *Thraliana* is one of the most important of the Huntington's manuscripts. In its six volumes, she followed Samuel Johnson's advice to "get a little book, and write in it all the little Anecdotes." She recorded observations about Johnson himself, as well as James Boswell, Oliver Goldsmith, and others.

The manuscript collections are especially strong for early nineteenth-century and Victorian novelists. For Charlotte Brontë there are more than 100 letters, most written to her close friend Ellen Nussey, as well as poems by Charlotte and her sisters Anne and Emily. For Charles Dickens there is a superb collection of 1,000 letters, many written to his friend and personal secretary William Henry Wills. They are joined by sets of original illustrations for *Nicholas Nickleby*, *Barnaby Rudge*, and *The Old Curiosity Shop*, all by Hablot Knight Browne ("Phiz"). William Makepeace Thackeray is represented by several literary drafts, more than 100 letters, and about 200 drawings.

Extensive Robert Louis Stevenson holdings include several volumes of journals and notebooks, the manuscripts for *The Beach at Falesa* and *Kidnapped*, the original diary on which *The Silverado Squatters* was based, and various notes on Hawaii and the South Seas, as well as ninety-one letters.

BELOW:
William Makepeace Thackeray (1811–1863) Drawing for *Notes of a Journey from Cornhill to Grand Cairo*, ca. 1845 Provenance unknown, HM 15358

An important 1976–81 addition to the nineteenth-century collections is the archive of English author Jane Porter, which consists of correspondence between Jane, her sister Anna Maria, her mother, and her brother Sir Robert Ker Porter, a diplomat posted to Russia. Jane Porter's novels *The Scottish Chiefs* and *Thaddeus of Warsaw* were bestsellers during her lifetime.

A cornerstone of the nineteenth-century American literary manuscripts is the papers of James T. Fields, a partner in the Boston firm of Ticknor and Fields and the editor of the *Atlantic Monthly*. With his wife, Annie, Fields held a central post in the publishing, cultural, and social circles of New England throughout much of the second half of the nineteenth century. Indeed, his influence extended beyond his own region to encompass authors in England as well. Literary correspondents include Henry Wadsworth Longfellow, Oliver Wendell Holmes, Sr. (who lived next door to Mr. and Mrs. Fields and dropped in frequently), Nathaniel Hawthorne (whose manuscript for *The Scarlet Letter* was discovered by Fields on a visit to the novelist's home, and thereupon published), Ralph Waldo Emerson, Edward Everett Hale, Julia Ward Howe, William Dean Howells, James Russell Lowell, Henry James, Harriet Beecher Stowe, Celia Thaxter, John Greenleaf Whittier, and Charles Dickens, who wrote:

> "If I come to America this next November, then you can hardly imagine with what interest I shall try Copperfield [his novel *David Copperfield*, first published in 1849–50] on our American audience, or, if they give me their heart, how freely and fully I shall give them mine."

The Huntington ranks as a principal center for Thoreau research, with drafts of *Walden* and *A Week on the Concord and Merrimack Rivers*, an early draft of part III of *The Maine Woods*, as well as letters and 186 pages from Thoreau's journal. In 1991 the collection was enriched with correspondence representing the Sewall family; Thoreau was a family friend, especially to Ellen Sewall, who declined his offer of marriage.

Similarly, the Library holds an important collection related to Samuel Clemens. Notable are the letters from Clemens to Mary Mason Fairbanks; the youthful Clemens had met her on board the *Quaker City* en route to the Holy Land in

ABOVE:

Charles Dickens
(1812–1870)
Autograph letter to
James T. Fields,
3 September 1867
Purchased from
A. S. W. Rosenbach,
1922; James T. Fields
Papers, FI 1211

If only birds of sudden white,
Or opal, gold or iris hue,
Came upward through the columned light
Of morning's ocean-breathing blue;

If only songs disturbed our sleep,
Descending from that wakeful breeze,
And no great murmur of the deep
Sighed in our summer-sounding trees!

—Wallace Stevens

1867, a trip made famous in his book *The Innocents Abroad*. In striking parallel to this correspondence, the Huntington received a bequest of a series of letters (with photographs) written by Clemens to Frances Nunnally Winzer, a young woman he met forty years later on board a ship bound for England, where Clemens would accept an honorary degree from Oxford University. The two became friends and continued to correspond and visit one another; Clemens even delivered the commencement address to Frances's high school graduating class.

Bridging the nineteenth and twentieth centuries, the Jack London collection, the largest literary collection in the Library, numbers some 50,000 items and is the largest London archive in the world. This vast trove of letters, photographs, and other material includes drafts and notes for nearly all his Klondike stories and novels, his tales of the South Pacific, and his nonfiction works. Complementing these London Papers are collections of papers by his daughter Joan London, and by Mary Austin, George Sterling, Anna Strunsky Walling, and others.

Since the 1970s, the Huntington has added extensively in modern fiction and poetry. The Wallace Stevens archive, acquired in 1975, includes a notebook of early poems entitled "The Little June Book" and six journals and commonplace notebooks. Many literary figures appear in Stevens's correspondence files, including Marianne Moore, Allen Tate, William Carlos Williams, and Robert Frost. Collections have also been acquired for American poets Henri Coulette, Robert Mezey, and Ann Stanford.

A sizable acquisition in 1980 is the archive of writer and journalist Patrick Balfour, third Baron Kinross, including his superb correspondence with fellow Oxford students, writers Evelyn Waugh, Cyril Connolly, Christopher Sykes, and Sir John Betjeman. Seven years later, the Library acquired the papers of English novelist Sir Kingsley Amis, with more material added in later years. At more than 600 items, the Amis collection is rich in drafts of his novels and stories, including several drafts of Amis's 1986 Booker Prize–winning novel *The Old Devils*; there are also extensive series of letters from authors Philip Larkin and Robert Conquest.

Archives of modern British authors also include the papers of Elizabeth Jane Howard, who has written more than a dozen novels, among them the trilogy *The Cazalet Chronicles*. In 2001 the Library acquired the archive of Hilary Mantel, author of such novels as *Every Day Is Mother's Day*, *Eight Months on Ghazzah Street*, and *The Giant, O'Brien*.

In 1999 the Huntington became the repository for the papers of Anglo-American author Christopher Isherwood. Perhaps best known for *The Berlin Stories*, the basis for the musical *Cabaret*, Isherwood is recognized as the first openly gay author to write for a wider audience. The Library's archive includes drafts of works like *The World in the Evening* and *A Single Man*, as well as correspondence from fellow authors W. H. Auden, Stephen Spender, E. M. Forster, and W. Somerset Maugham.

Drawings by internationally known portrait artist Don Bachardy capture many of the individuals represented in the Isherwood papers. Bachardy's art hangs in such venues as the Metropolitan Museum in New York City, the Smithsonian in Washington, D.C., and the National Portrait Gallery in London.

Representing a far different area of art, the papers of editorial cartoonist Paul Conrad, acquired by the Library in 1994, include about 10,000 original drawings, along with files of speeches and both fan and hate mail. The winner of three Pulitzer Prizes and many other awards, Conrad was the editorial cartoonist for the *Los Angeles Times* from 1964 to 1993.

In 2002 the Huntington acquired a superb small collection of letters and manuscript drafts by Langston Hughes. This material includes a small pocket diary Hughes kept during his 1932 trip through Asia, plus letters to Los Angeles attorney and judge Loren Miller and an autograph draft of a poem entitled "Wise Men."

The Library continues to acquire new manuscript material, building to collecting strengths, while extending the holdings into the twenty-first century.

BELOW:
Paul Conrad (1924–)
Drawing of Richard Nixon, 19 March 1974
Gift of Kay and Paul Conrad, 1993; Conrad Papers
Reproduced with permission, Paul Conrad, *Los Angeles Times*, 1974

PERCY BYSSHE SHELLEY

The unconventional Shelley, after abandoning his first wife, Harriet, and marrying Mary Godwin, moved to Italy in 1818. During 1818–19, he wrote some of his most important verses, including "Ode to the West Wind," "To a Skylark," and his great lyrical drama *Prometheus Unbound*. The Huntington owns three extraordinary Shelley notebooks, in which he recorded his thoughts and drafts of poems, interspersed with random drawings.

Yet look on me take not thine eyes away
Which feed upon the love within mine own
Although it be but the reflected ray
Of thy beauty from my spirit th[rown]
Yet speak to me! thy voice is as the tone
Of my heart's echo, and I think I hear
That thou yet lovest me—Yet tho[u] [?alone]
Like one before a mirror, [take] [?no] care
Of aught but thine own [?]
 [imaged] too truly there[e]
And yet I wear out life in watching thee
Whether thou lovest me as [looks] have [?said]

CHARLOTTE BRONTË

Brontë writes about reviews of her novel *Jane Eyre* to Williams, a reader for its publisher, the firm Smith and Elder. Published in late 1847, the book received rave reviews and was immediately successful with the public. In this letter, signed with Brontë's pen name "Currer Bell," she discusses her novel's depiction of insanity and notes with satisfaction the response of a neighbor to the book.

HARRIET BEECHER STOWE

Stowe wrote to Denman, himself an outspoken abolitionist, about her reasons for writing the powerful anti-slavery novel *Uncle Tom's Cabin*, saying, "I *must* speak for the oppressed—who cannot speak for themselves." The book became very popular and made its author both one of the most admired and most reviled public figures of her time. Stowe wrote so prolifically to help support her family that she developed trouble with her hand and often employed one of her daughters as a secretary.

HENRY DAVID THOREAU

Thoreau lived for two years (1845–47) in
a cabin he built on the shore of Walden Pond
near Concord, Massachusetts. He offered
this reason for his solitary experiment:
"I went to the woods because I wished to live
deliberately, to front only the essential facts
of life, and see if I could not learn what it
had to teach, and not, when I came to die,
discover that I had not lived." Thoreau wrote
and rewrote this book many times before its
publication in 1854. The Huntington has
seven different versions, plus the corrected
proofs. On this first page of one draft,
Thoreau has written the first paragraph
around his sketch of a rooster.

W. H. Auden

Auden was one of a group of young English poets who sought to bring new techniques and attitudes to English poetry. His verses demonstrated the use of wit, irony, and deep but unsentimental feeling. "Before," written early in Auden's career, displays imagery central to the poet's development and foreshadows motifs that would appear again in later works. In this draft, the poem differs from the published text.

A SINGLE MAN

Waking up begins with saying **am** and <u>now</u>. That which has awoken then
lies for a while staring up at the ceiling and down into itself until it
has recognized <u>I</u>, and therefrom deduced <u>I am</u>, <u>I am now</u>. <u>Here</u> comes next,
and is at least negatively reassuring ; because <u>here</u>, this morning, is
where it had expected to find itself ; what's called <u>at home</u>.

But <u>now</u> isn't simply now. <u>Now</u> is also a cold reminder ; one whole
day later than yesterday, one year later than last year. Every <u>now</u> is
labeled with its date, rendering all past <u>nows</u> obselete, until --- later
or sooner --- perhaps --- No, ~~Not~~ perhaps, *-- quite certainly :* ~~It is quite certain~~. It
will come.
 Fear tweaks the vagus nerve. A sickish shrinking from what waits,
 ~~An abrupt twitch of fear on the vagus nerve.~~
Somewhere out there, dead ahead.
~~But~~ Meanwhile the cortex, that grim~~ly anxious~~ disciplinarian, has taken its
place at the central controls and has been testing them, one after an-
other --- the legs stretch, the lower back is arched, the fingers clench
and relax. And now, over the entire intercommunication-system, is iss-
ed the first general order of the day : UP.
 Obediently, the body ~~hoists~~ *levers* itself out of bed --- wincing from twinges
in the arthritic thumbs and the left knee, mildly nauseated by the pylor-
us in a state of spasm --- and shambles naked into the bathroom where its
bladder is emptied and it is weighed; ~~it~~ still a bit over 150 pounds,
in spite of all that toiling at the gym ! Then to the mirror.

What it sees there isn't so much a face as the expression of a pre-
dicament. Here's what it has done to itself, here's the mess it has
somehow managed to get itself into, during its fiftyeight years; ~~it~~ ex-
pressed in terms of a dull harassed stare, a coarsened nose, a mouth
dragged *down* by the corners into a grimace as if at the sourness of its own
toxins, cheeks sagging from their anchors of muscle, a throat hanging
limp in tiny wrinkled folds. The harassed look is that of a desperately
tired swimmer or runner ; yet there is no question of ~~the possibility~~

CHRISTOPHER ISHERWOOD

A Single Man, considered by many to be Isherwood's
masterpiece, was one of the first important gay
novels to reach a wide audience. A poignant tale of
loss and survival, it tells the story of a man coping
with the death of his life companion.

Printed Books

APOLOGVS.

Tauano cantando le ranochie ad gran folazo alle herbezole che in tor
no de uno lacho de freſchiſſima aqua erano acaſate & in loro conſiglio
tuɛte inſieme deliberaro auere uno Re & in della loro deliberatione fero

Incunabula

"Incunabula" is one of those words that can stop the conversation at cocktail parties, but what does it mean? *Cuna* is Latin for "cradle," and incunabula (accented on the third syllable) comprised the apparatus of the cradle, including the straps that held the baby in. A Roman could use either word figuratively to refer to his origins, his "roots." In the world of books an incunabulum or incunable (the anglicized form) is defined as anything printed from the invention of printing in the West (roughly 1450) through 1500. This arbitrary fifty-year limit is so entrenched in bibliography that a book published in 1501 might today be valued at only two-thirds the price of a similar book printed in the previous year.

Quite early in his career as a serious bookbuyer, Huntington acquired the jewel of his incunabular crown, the Gutenberg Bible. Other purchases brought the total to 400 in ten years. But his acquisition of the Charles Gunther collection of seventy incunabula in 1922 seems to have really gotten the juices flowing. Over the next four years he bought 4,500 more, most of them in three large lots from a particularly importunate dealer named Otto Vollbehr. This slightly shady individual, who had a later career as a Nazi propagandist, seems to have played on Huntington's competitive streak and growing desire to send the institution into the world with the best scholarly credentials. The Vollbehr purchases contained many "ordinary" editions—as incunabula go—but also some significant rarities, such as a group of Spanish imprints that are among the most intensively studied fifteenth-century books at the Huntington.

The Huntington's current total of close to 5,300 incunabula (not counting second copies) places it first, by a nose, among libraries in the New World. (The Library of Congress probably has more volumes, but also more duplicates and fewer distinct editions.) Almost twenty percent of all surviving editions from the fifteenth century are represented.

GUTENBERG BIBLE

Some people thought Henry Huntington was mad when he bought this 53-pound, two-volume set in 1911 for $50,000—a record price for a book for an American auction. But nothing speaks more eloquently of the break between the medieval and modern worlds than the stately march of unfaded black letters in Gutenberg's massive production. And in purely financial terms, as an attraction to visitors it must be one of the few books in the Library that has paid its own way. The Huntington copy was illuminated and bound in Germany soon after its printing, but otherwise its pedigree before about 1600 is a blank. Since then, records show that seven individuals, a university, and a noble family have owned it. One of eleven known copies printed on vellum (of a total of forty-eight surviving), it is taller than most of the rest and still has its original pigskin binding. This first mass-produced Bible caused amazement when early sheets were publicly displayed in 1454. Today the remnants of that edition continue to amaze . . . and to puzzle. Recent studies have cast doubt on our assumptions about Gutenberg's basic typefounding methods. As a thing of both beauty and curiosity, Huntington's not-so-mad purchase remains the jewel of his printed books.

BELOW:
Biblia Latina
[Mainz: Johann Gutenberg, ca. 1455]
Robert Hoe copy, purchased in 1911;
RB 92588

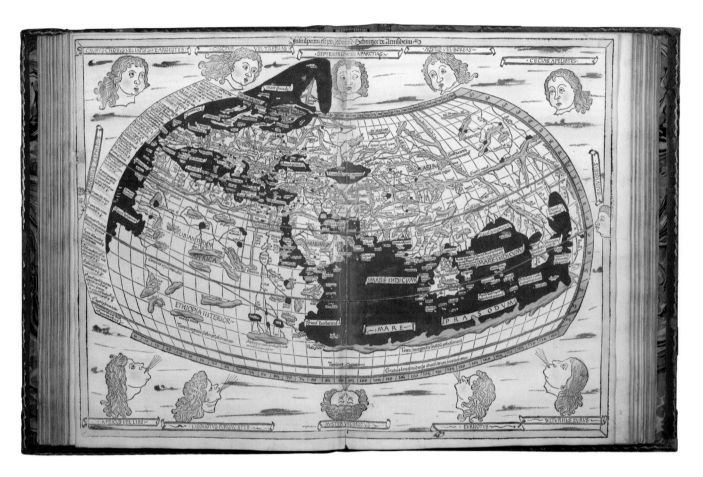

THE WORLD IN 1482

The first printed maps to show the world in any detail were derived, not from firsthand observations, but from data assembled by an Egyptian 1,300 years earlier. Claudius Ptolemaeus (Ptolemy) may never have drawn a map himself, but he compiled geographical coordinates—mostly from earlier authors—for some 8,000 locations. Medieval mapmakers used these to generate "Ptolemaic maps," which gave the best available view of the world before the Age of Exploration.

This German woodcut version of the Ptolemaic world map, flanked by twelve windheads, shows the start of post-Classical additions—the flap at the top contains jumbled chunks of Scandinavia. Ptolemy's too-small estimate of the circumference of the earth, and his exaggeration of the eastward extension of the Asian landmass, encouraged Columbus to believe he had reached the Indies on his landfall ten years after this map was published.

ABOVE:
Claudius Ptolemaeus
Geographia
[Ulm: printed by
Lienhart Holle,
1482]
Probably purchased
from Otto Vollbehr;
RB 105406

THE TWELVE LABORS OF HERCULES

With Spain we pass outside the mainstream of medieval European tradition. The woodcuts illustrating this moralized retelling of the Labors of Hercules seem more like the products of German Expressionism than of northern Spain at the end of the fifteenth century. This one shows the wrestling match between Hercules and the giant Anteus, son of the earth goddess Gaia. Because of the giant's kinship with the earth, whenever he was thrown to the ground he arose with renewed strength. When Hercules finally realized this, he lifted Anteus off the ground and was able to crush him to death. As with the other eleven labors, this fable is followed by a Christian interpretation. The giant Anteus represents man's carnal and bestial nature, which takes its strength from the earth but can be vanquished if it is removed from its mundane connection and elevated toward heaven.

THE LANDINO DANTE

This is the first illustrated edition of Dante's *Divina Commedia*, with drawings by Sandro Botticelli rendered in copperplate engraving. The printer left spaces for illustrations to most of the 100 cantos, but apparently the artist could not keep up, and only the first nineteen were ever completed. Most of these, like the one shown here, were printed on separate sheets pasted in. The interpretations of the hired engraver range from charming to slightly clumsy. This is also the first edition of the *Commedia* to be printed in Dante's home city of Florence, and the first with the valuable commentary of Christoforo Landino, which quite swallows up the original text.

THE SUBIACO LACTANTIUS

In most European countries the first printing was done by German immigrants. Conrad Sweynheym and Arnold Pannartz had the honor of introducing printing to Italy, setting up their press at a monastery fifty miles east of Rome. This collected works of Lactantius, a Christian apologist of the late Roman Empire, was one of four books they printed there before moving on to Rome. Although they sometimes joked about their "rough Teutonic surnames," Sweynheym and Pannartz added that perhaps the art of their printing would mitigate the harsh effect. And indeed, their books show how beautifully a job can be done using only one size of type and no pictures. (They had no hand in the illuminated initials in the Huntington's copy.) This printing type, used only in their Subiaco publications, was revived in the twentieth century for use in fine editions by the Ashendene Press.

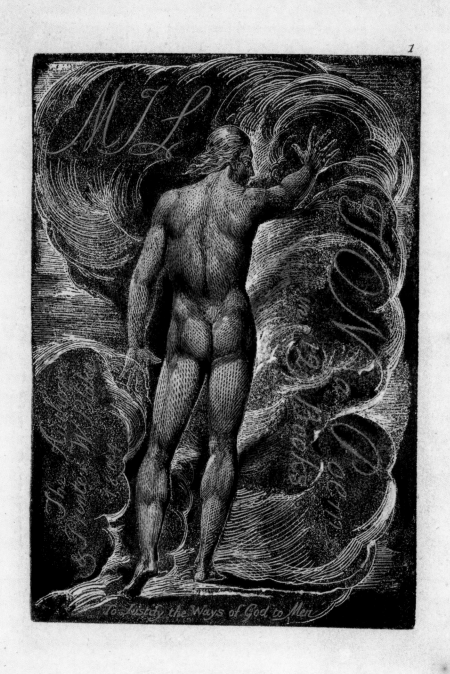

To Justify the Ways of God to Men

Books of the British Isles

Huntington's short library-building career coincided with—and caused, to some degree—the most overheated antiquarian book market of the twentieth century, which fizzled out two years after his death in 1927. It was a particularly fine time to buy early literature and history of the British Isles. One source of the abundance was a collection of 200,000 to 300,000 volumes formed by Richard Heber (1773–1833)—probably the largest private library ever assembled. Much of Heber's English material was bought by William Henry Miller (1789–1848) and after passing to Miller's heirs, became known as the Britwell library. It took eleven years to auction off this massive collection, and Huntington dominated the sales.

The works of William Shakespeare were a powerful engine driving both Anglo-American literary scholarship and book collecting in the early twentieth century. Huntington achieved a personal goal to rival the British Library's holdings of Shakespeare's early editions. By the time he died, the two institutions were virtually neck and neck; each now owns seventy-one of the individually published plays before 1640. (Both run a distant second to Henry Folger's achievement of 152 play quartos and nearly 80 First Folios.) But Huntington's Shakespeariana was only one focus of his vast collection of early English books—both non-fiction and literature—which now contains copies of fully a third of the surviving editions printed before 1640. Among the rarities are the first books printed in English; the first English book on swimming, showing woodcuts of skinny-dipping Elizabethans; and rare collections of madrigals and lute music.

The Huntington has tried to document every aspect of life in the British Isles up to the Civil Wars of the 1640s. The relaxation of censorship resulting from those wars encouraged the production of a flood of controversial pamphlets and periodicals. Even so, the Library's coverage of imprints from 1641–1700 is more than respectable, with copies of more than thirty percent of surviving editions in the collection. The eighteenth century, with its exponential rise in printing activity, is untamable by any one library. With nearly 50,000 eighteenth-century English books, the Huntington far exceeds the holdings of any other institution in the United States outside the combined Harvard libraries.

FAR LEFT:
William Blake
Milton a Poem
[London], 1804[-08?]
Robert Hoe copy,
purchased in 1911;
RB 54041

THE FIRST BOOK PRINTED IN ENGLISH

The *Recuyell* [Collection] *of the Historyes of Troye*, a chivalric recasting of various myths associated with the legendary city, is not a work that most of us would have chosen to be the first thing printed in English. To understand why it was, we need to know a bit about the printer. William Caxton, a cloth merchant born in Kent, had moved to the Low Countries while still a young man. Over the space of thirty years, he made

a tidy fortune and became a senior member of the large expatriate community of English merchants in Bruges. The region was at that time part of the duchy of Burgundy, and the Duchess of Burgundy, Margaret of York, was sister to the English king Edward IV. Through these associations, Caxton was introduced to the recently written *Recueil des histoires de Troie*, then circulating in manuscript in the original French. Its

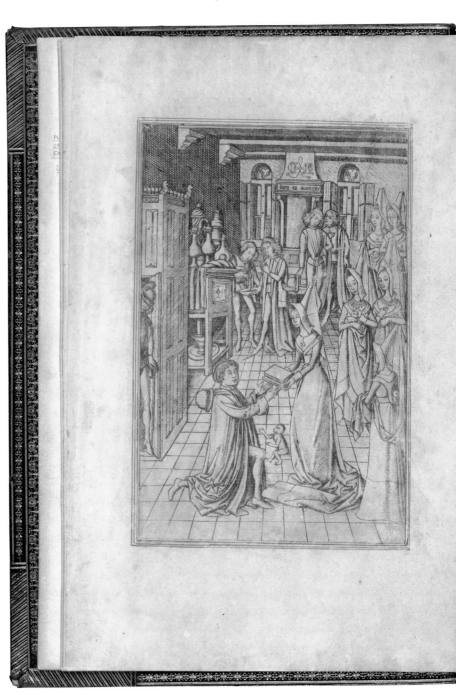

author, Raoul Lefèvre, had been a chaplain to the previous duke. Encouraged by his countrywoman the duchess, Caxton translated the book into English. Some time around 1471, following a reversal of fortune, he moved for a couple of years to Cologne, where printing had already been introduced. Perhaps he was searching for a second career, for when he returned to Bruges in 1473 he had learned how to print, and his cloth-dealing days were over. He introduced printing to that city, and his first production was his own translation of the *Recueil*. Three years later he returned to England, thus becoming the first printer there as well, with a shop in Westminster. The contemporary engraving bound with this copy shows Caxton presenting his *Recuyell* to the duchess. It is the only example known, and the only plausible likeness of England's first printer.

ANATOMICAL CHART

This splendid anatomical chart was printed around 1562 for Giles Godet, a French-born publisher of woodcuts working in London. The figure of the man, who holds his left hand in a phlebotomy basin, shows the veins used in medical bloodletting. Both the man and the woman also have movable overlays—five and six respectively, printed and cut with great care—that give a detailed view of the internal organs. The woman holds a sign

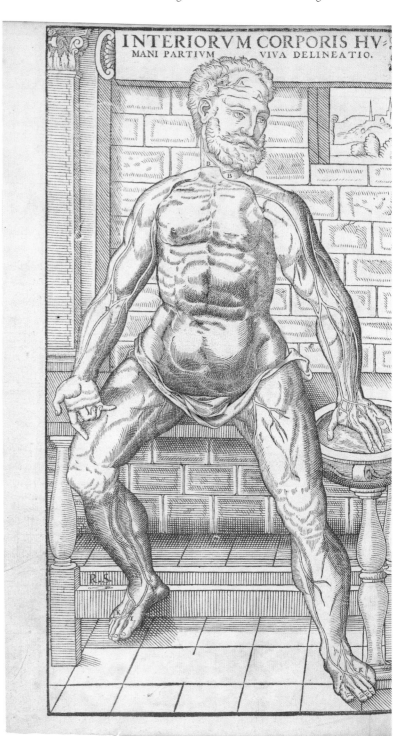

reading "Knowe thy self," and the accompanying text calls the chart "very necessarie . . . to phisitians and surgians and all other that desyre to knowe them selves." Instead of marketing this chart to a closed group of medical professionals, Godet evidently felt it was appropriate for all women and men to learn as much as they wanted about their own bodies.

THE "BAD QUARTO" OF *HAMLET*

"To be, or not to be, I there's the point,
To Die, to sleepe, is that all? I all:
No, to sleepe, to dreame, I mary there it goes."

This is how Hamlet's soliloquy begins in the first edition of William Shakespeare's most famous play, published in 1603. Incoherent passages like this one blemish nearly every page, and the whole is only about sixty percent of the version we read today. How did Hamlet get so scrambled? Early editors noticed that the text improves whenever Hamlet's friend Marcellus is on stage. It is thought that somebody asked the actor who played that character to reconstruct this first *Hamlet* from memory. Textual infelicities

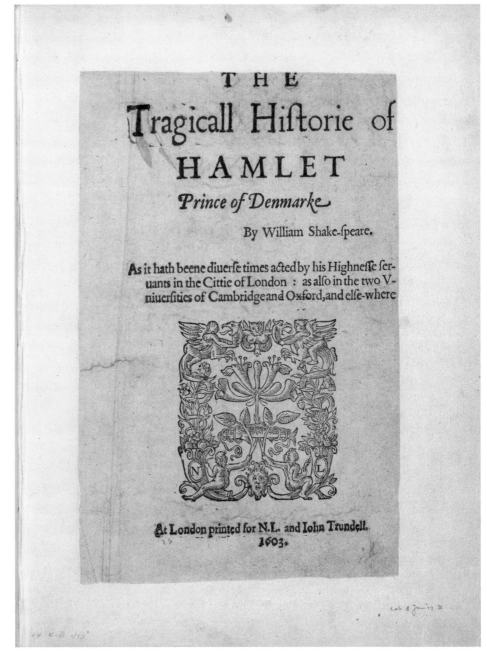

notwithstanding, some scholars feel it "plays" better than the longer text in terms of action, and suggest it is descended from a stripped-down version designed for a band of traveling players who gave the provincial performances to which the title page alludes. The actor's memory acts like a distorting lens between us and the intriguing image whose details we are still trying to make out. The Huntington copy of this edition is one of only two that survive, and the only one with its title page. Discovered in a closet in Cheshire in 1823, "barbarously cropped, and very ill-bound," it was subsequently cut apart and the leaves were individually mounted in an overzealous act of piety. We are lucky to have it at all.

The Tragedy of Hamlet

And so by continuance,and weakenesse of the braine
Into this frensie, which now possesseth him:
And if this be not true, take this from this.
 King Thinke you t'is so?
 Cor. How? so my Lord, I would very faine know
That thing that I haue saide t'is so, positiuely,
And it hath fallen out otherwise.
Nay, if circumstances leade me on,
Ile finde it out,if it were hid
As deepe as the centre of the earth.
 King. how should wee trie this same?
 Cor. Mary my good lord thus,
The Princes walke is here in the galery,
There let *Ofelia,*walke vntill hee comes:
Your selfe and I will stand close in the study,
There shall you heare the effect of all his hart,
And if it proue any otherwise then loue,
Then let my censure faile an other time.
 King. see where hee comes poring vppon a booke.
 Enter Hamlet.
 Cor. Madame, will it please your grace
To leaue vs here?
 Que. With all my hart. *exit.*
 Cor. And here *Ofelia,* reade you on this booke,
And walke aloofe, the King shal be vnseene.
 Ham. To be,or not to be, I there's the point,
To Die, to sleepe,is that all? I all:
No,to sleepe,to dreame, I mary there it goes,
For in that dreame of death, when wee awake,
And borne before an euerlasting Iudge,
From whence no passenger euer retur'nd,
The vndiscouered country, at whose sight
The happy smile,and the accursed damn'd.
But for this,the ioyfull hope of this,
Whol'd beare the scornes and flattery of the world,
Scorned by the right rich,the rich cursed of the poore?
 The

ABOVE:
Hamlet's soliloquy in the 1603 First Quarter (above) and the more familiar version in the 1604 Second Quarto (right); RB 69305

Prince of Denmarke.

We will bestow our selues; reade on this booke,
That show of such an exercise may cullour
Your lowlines; we are oft too blame in this,
Tis too much proou'd, that with deuotions visage
And pious action, we doe sugar ore
The deuill himselfe.
 King. O tis too true,
How smart a lash that speech doth giue my conscience.
The harlots cheeke beautied with plastring art,
Is not more ougly to the thing that helps it,
Then is my deede to my most painted word :
O heauy burthen.

 Enter Hamlet.
 Pol. I heare him comming, with-draw my Lord.
 Ham. To be, or not to be, that is the question,
Whether tis nobler in the minde to suffer
The slings and arrowes of outragious fortune,
Or to take Armes against a sea of troubles,
And by opposing, end them, to die to sleepe
No more, and by a sleepe, to say we end
The hart-ake, and the thousand naturall shocks
That flesh is heire to; tis a consumation
Deuoutly to be wisht to die to sleepe,
To sleepe, perchance to dreame, I there's the rub,
For in that sleepe of death what dreames may come
When we haue shuffled off this mortall coyle
Must giue vs pause, there's the respect
That makes calamitie of so long life:
For who would beare the whips and scornes of time,
Th'oppressors wrong, the proude mans contumely,
The pangs of despiz'd loue, the lawes delay,
The insolence of office, and the spurnes
That patient merit of th'vnworthy takes,
When he himselfe might his quietas make
With a bare bodkin; who would fardels beare,
To grunt and sweat vnder a wearie life,
But that the dread of something after death,
The vndiscouer'd country, from whose borne.
 G 2 **No**

THE COMPLEAT ANGLER

Many potential readers of Izaak Walton's famous book have never attempted it because they assume it is a fishing manual. It does give pointers on catching fish, along with recipes, snippets of folklore, observations on natural history, reminiscences, songs, and homespun philosophy. But it would be truer to say that *The Compleat Angler* is mainly about friendship. Probably the most amiable book ever written, it has sent countless readers back into the world with a smile and a good appetite. Some book collectors make a specialty of this title alone, in its innumerable editions. The pocket-sized first version is the hardest to get, and the Huntington's copy remains in its original plain calf binding.

The
Compleat Angler
or the
Contemplative man's
Recreation.

Being a Difcourfe of
FISH and FISHING,
Not unworthy the perufal of moft *Anglers.*

Simon Peter *said, I go a* fifhing : *and they said, We
also wil go with thee.* John 21.3.

London, Printed by *T. Maxey* for RICH. MARRIOT, in
S. Dunftans Churchyard Fleetftreet, 1653.

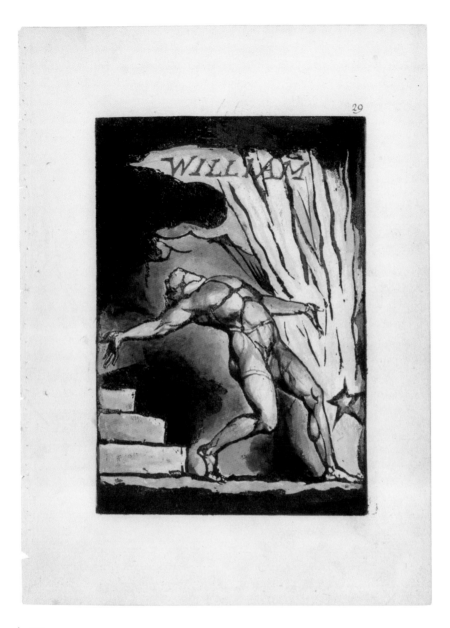

BLAKE'S *MILTON*

It would be hard to name an individual other than William Blake (1757–1827) who now has as great a reputation as both an artist and a poet. During his lifetime, and for decades after, his eccentricity and penchant for inventing elaborate private mythologies fully earned him the label "neglected genius." His beautiful and startling illuminated books, not widely reproduced until recent times, played a large part in building his posthumous reputation. These he made by an ingenious process, not used since, involving relief copper printing plates, the results often finished with hand-coloring. *Milton*, whose forty-five plates Blake worked at for several years starting in 1804, has a rolling thunderstorm of a text that not even the experts claim to understand fully. John Milton's works were a touchstone for Blake, and this is the central document of his lifelong dialogue with the author of *Paradise Lost*. Of this very handmade book he may have printed ten copies, maybe a few more, but only four survive today, each with different coloring.

THE
BOOK OF THE GENERAL

LAUUES AND LIBERTYES

CONCERNING THE INHABITANTS OF THE MASSACHUSETS

COLLECTED OUT OF THE RECORDS OF THE GENERAL COURT
FOR THE SEVERAL YEARS WHERIN THEY WERE MADE
AND ESTABLISHED,

And now revised by the same Court and disposed into an Alphabetical order
and published by the same Authoritie in the General Court
held at *Boston* the fourteenth of the
first month *Anno*
1647.

Whosoever therefore resisteth the power, resisteth the ordinance of God,
and they that resist receive to themselves damnation. Romanes 13. 2.

CAMBRIDGE.
Printed according to order of the *GENERAL COURT.*
1648.

And are to be solde at the shop of *Hezekiah Usher*
in *Boston.*

American Books

On the evening of December 18, 1919, Huntington hosted a gathering of members of the Authors Club of New York to view "his remarkable library of American history, English literature, manuscripts, etc." This event gives us the opportunity to speculate on Huntington's favorite books and manuscripts and to determine the scope and direction his collecting was taking at the time—shortly after signing his first trust indenture to open his library to the public and shortly before it was moved west to California.

Of the thirty-six items on display, half were English and half were American. Almost all the English items were great literary works; all but one of the American ones dealt with early America or the founding fathers. Five of the American works were some of the rarest and most desirable imprints of the English colonies: the Bay Psalm Book (1640), the first book in English published in America; John Winthrop's *A Declaration of Former Passages and Proceedings betwixt the English and the Narrowgansets* (1645), the first book on a historical subject in English America; *The Book of the General Lawes...of the Massachusets* (1648), the only known copy of the first printed collection of the laws of the Colony; the Eliot Bible (1663), the first Bible printed in any tongue in English America; and Robert Hunter's *Androboros* (1714), one of three known copies of the first play printed in America.

From all indications, Huntington's first really serious collecting interests were English literature and early American history dealing with the discovery and colonization of America and the founding of the Republic. He was also fascinated by the historical, literary, political, and cultural connections between England and America, and his library was intended to prove and promote their common heritage. As his library grew and his vision evolved, he concentrated on collecting English and American history and literature—a remarkably broad field for a collector who wanted everything important and rare up through the nineteenth century.

In April 1911, Huntington made his most formative acquisition—the library of Elihu Dwight Church. This move set his standards high and framed his interests, particularly in the field of Americana. (Of the thirty-six items on display in New York, eleven were from the Church library.) This was the ultimate en bloc purchase, and obviously the best foundation one could have to build a truly great American collection. From George Brinley's library and other nineteenth-century collections, Church had acquired accounts of European explorers and publications dealing with French, Spanish, and especially English colonization. There were editions of Columbus, Vespucci, Cortés, and Las Casas and narratives of Hakluyt, Ramusio, and Purchas. Early English Colonial material down through the Revolution included printed sermons, almanacs, primers, and legal and literary works from the north and south—many of them exceedingly difficult to obtain, even at the turn of the twentieth century.

After receiving the Church library, Huntington immediately commenced buying early American books he did not already have. Depth and breadth were the hallmarks of his collecting, making him the principal rare book buyer in the United States for seventeen years. After Huntington acquired Augustin Macdonald's 1,500-volume library dealing with California and the West, Henry Raup Wagner noted that "Mr. Huntington bought two kinds of books—those in which he was interested and those he thought he should buy to include in his library." Huntington bought four Western American and Mexican imprint collections from Wagner himself. Probably few really captivated him.

But there were many other major and small purchases that did absorb Huntington and resulted in the building of an outstanding library of Americana. Prominent New York lawyer and fellow Grolier Club member Frederick Halsey sold his literature collection of 20,000 volumes to Huntington, significantly augmenting the American literary holdings. From naval bibliographer Charles Harbeck he received 700 volumes dealing with the history of the Navy. Colonel John Page Nicholson had voraciously assembled some 10,000 printed items dealing with the military history of the Civil War; his heirs sold it to Huntington in 1922. A large collection of *Beadle's Dime Novels* and other Beadle's pulp publications were acquired

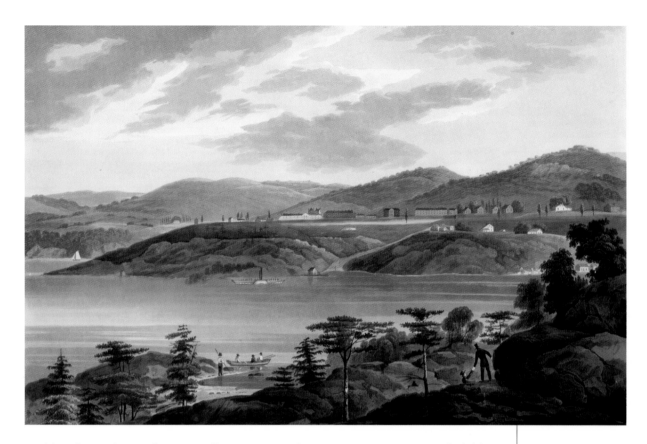

en bloc from the Anderson Galleries in October 1922. From New York bibliographer and librarian Wilberforce Eames in 1923 came a 12,000-piece collection of nineteenth-century regional and local imprints, which was probably the largest single acquisition of Americana Huntington ever made.

Robert Schad, former curator of rare books, once speculated that if Huntington had lived many years longer, he would have added significantly to the 55,000 volumes of Americana that came in before his death in 1927. His staff was organized to bring collecting into the twentieth century, and, in fact, they were methodically buying modern literature and, as usual, filling in and looking for new author and subject collections.

This *modus operandi* has been perpetuated after his death by both gifts and purchases. Major new collections include American fiction up to 1900 used by Lyle Wright for his bibliographical series; authors' libraries (including John Muir, Jack London, and Wallace Stevens); and the continued expansion of the Western American and California collections into Mormon history, California utopianism, maritime history, and many other topics. The Library has systematically acquired city directories, guidebooks, gift books, almanacs, newspapers, sheet music, and many other formats and genres.

LETTER OF CHRISTOPHER COLUMBUS

The first announcement of Christopher Columbus's voyage of discovery (3 August 1492–14 March 1493) came in a group of three very similar letters to the Spanish Court, which Columbus composed at sea as he was returning home. Two of these letters—addressed to Luis de Santángel and Rafaél Sánchez—were quickly printed in Spanish, translated into Latin and German, and paraphrased into Italian verse by Giuliano Dati. The Sánchez letter, which first appeared in Rome in 1493, was reprinted many times and provided the first real information on the New World. All of the early editions of the Columbus letter are extremely rare. Dati, the Italian poet and bishop, rendered the Columbus letter into Italian metrical verse, and it was printed in at least four editions in Florence. Apparently, only two copies of this 26 October 1495 edition are known. It includes a beautiful woodcut designed in the Florentine style depicting King Ferdinand, Columbus's three vessels, and a group of long-haired native Americans. The Huntington has five editions of the Sánchez Columbus letter printed before 1500.

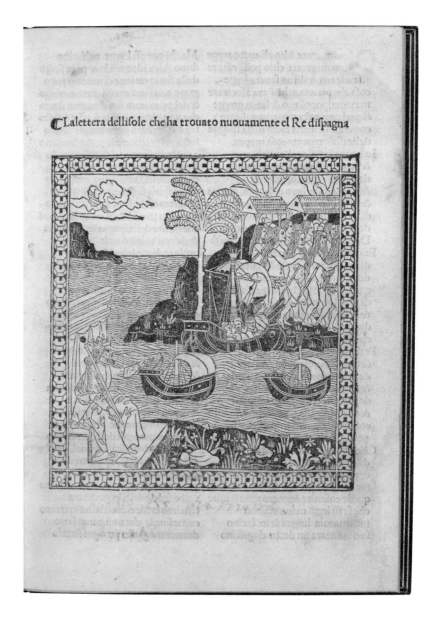

Lalettera dellisole che ha trouato nuouamente el Re dispagna

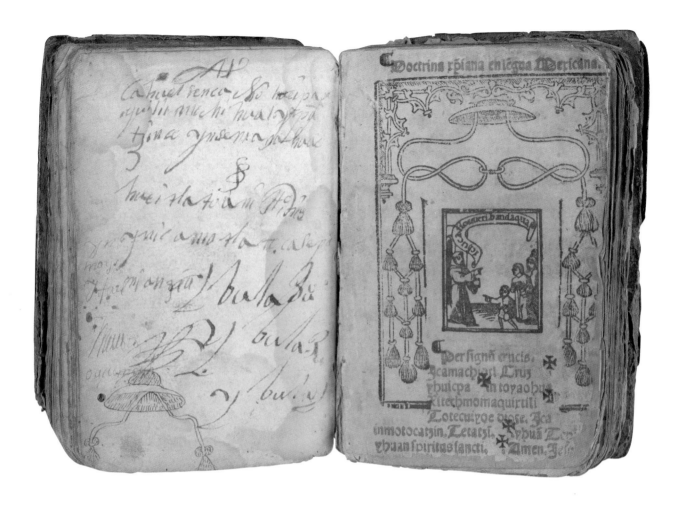

Doctrina Cristiana

This little catechism, which includes the Pater Noster and Ave María along with articles of Roman Catholic faith and teaching, was one of many early Doctrinas prepared for use by the Mexican church to proselytize and teach. Its significance, however, is that it is considered the first Nahuatl imprint of the first printed book to transliterate Nahua—the language of the Aztecs—using Spanish letters. Although very little is entirely clear about early printing in Mexico, it is believed that Juan Cromberger of Seville with support and assistance of Juan Zumárraga, Bishop of Mexico, established the first printing press in Mexico around 1539. The operator of the press was Juan Pablos, who printed almost exclusively religious works. The small woodcut on the title page shows natives and a priest who is proclaiming "This is the Word of God." The binding of the leather over boards is probably the original local binding. This is the only surviving copy of this printing.

ABOVE:
Doctrina cristiana en lengua Mexicana..., [Mexico: Juan Pablos, 1547?] Purchased from Henry R. Wagner, 1923; RB 106310

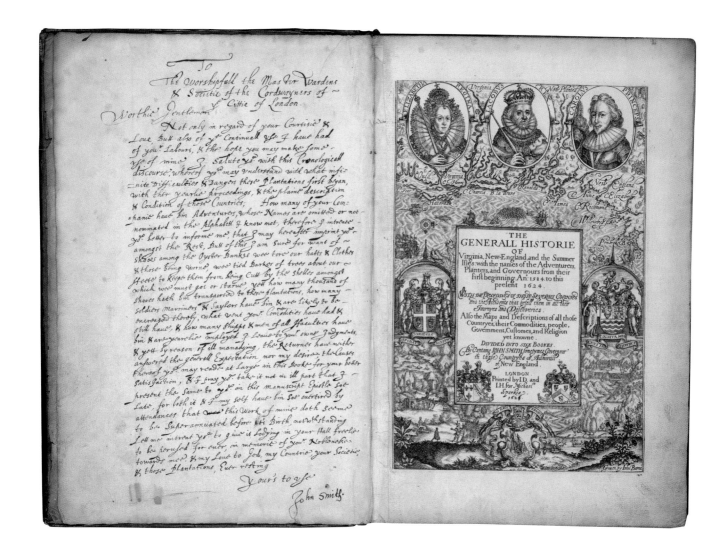

JOHN SMITH'S *GENERALL HISTORIE*

One of the most important early accounts of the English colonies was that written by Captain John Smith. Smith helped organize the Virginia Company and in 1607 crossed the Atlantic and founded Jamestown, the first permanent English settlement in North America. In his *Generall Historie*, he tells the romantic story—perhaps entirely imaginative—of how the Indian princess Pocahontas dramatically rescued him from execution. This copy was presented by Smith

"To the Worshipfull the Master Wardens & Societie of the Cordwayners [i.e. shoemakers] of the Cittie of London" and is inscribed with a long dedication. Smith writes in part: "I salute you with this Cronologicall discourse whereof you may understand with what infinite Difficulties and Dangers these Plantations first began with their yearlie proceedings, & the plaine description & Condition of those Countries." The binding bears the royal arms of King James I of England.

NEW ENGLAND PRIMER

This book measuring 7 x 9 cm is possibly the earliest-known complete copy of what has been called "The Little Bible of New England." A primer is an elementary book for teaching children to read, but primers were much more than that to Puritans. They were meant to instill Christian values and teachings at a very young age. The *New England Primer* taught the alphabet as well as Christian creeds. Puritans wanted everyone to read, understand, and obey God's holy scriptures; therefore, education was of paramount importance. Benjamin Harris, who fled London for Boston in 1686, probably printed English America's first primer that year. Millions of primers were produced thereafter, but most of them were destroyed by zealous readers. The contents of primers varied according to tastes and business interests; they usually contained the alphabet, a syllabarium, alphabet rhymes with pictures, the Ten Commandments, prayers, and some psalms. This 1735 edition included John Cotton's *Milk for Babes*, New England's first catechism, which was initially printed in London in 1646.

LEFT AND BELOW:
The New-England Primer Enlarged. For the more easy attaining, the true Reading of English. To which is added, Milk for Babes
[Boston: S. Kneeland and T. Green, 1735]
Purchased as part of the E. D. Church library, 1911; RB 14802

CINDERELLA

The origin of the ancient fairy tale of Cinderella is unclear, but more than 500 versions have been recorded in Europe alone. The English version came through a translation of Charles Perrault's "Cendrillon," which appeared in *Contes de ma mere l'oye* (Tales of Mother Goose) in 1697. In 1800 Mathew Carey, one of the most prominent U.S. publishers and booksellers, had his brother James Carey print 1,000 copies of this thirty-two-page book. Of those copies, only the one in the Huntington has survived. This is the first separate and dated American edition of *Cinderella*, which is illustrated with very crude oval woodcut engravings, including the frontispiece showing an over-burdened Cinderella. The first owner of this book has written her name on the front fly leaf: "Sarah Walsh's Book December 4th 1800." It is obvious she cared for her book dearly.

MARK TWAIN

Mark Twain's *Jumping Frog* sketch is probably the most famous tall tale in American literature. The story itself came out of the California Gold Rush of the 1850s, but it was Twain's telling—the yarn spun by narrator Simon Wheeler and the characterization of the obsessive gambler Jim Smiley and his menagerie of performing animals, including Andrew Jackson the fighting dog and Dan'l Webster the jumping frog—that has made it a permanent fixture of American folklore. The Twain version was first published on November 18, 1865, in the New York *Saturday Press*, after his manuscript failed to reach Artemus Ward for inclusion in a collection of Western stories. It was republished in newspapers across the country, bringing national attention virtually overnight to the young journalist Samuel Clemens, who had been working in Virginia City, Nevada and California. It first appeared in book form in 1867. Because the *Jumping Frog* was reprinted so many times, and because Twain was concerned about the handling and spelling of the Pike County dialect, he repeatedly corrected and revised the text. In this 1869 edition, he made many alterations in his own hand, some of which appeared in later editions. The illustration is open to the passage about Smiley's bull pup, Andrew Jackson.

ABOVE:
Mark Twain
The Celebrated Jumping Frog of Calaveras County: And Other Sketches
[New York: C. H. Webb, 1869]
Purchased from the Doheny Sale by the Dan Murphy Foundation, 1989;
RB 488946

History of Science and Technology

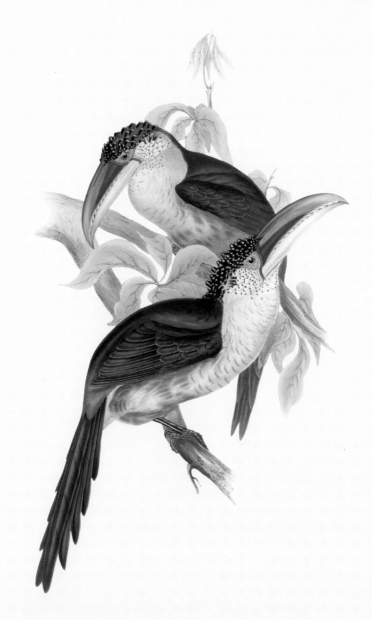

The Library's holdings in the history of science constitute a rich tapestry documenting the history, transition, and growth of fundamental areas of scientific inquiry from the twelfth century up to the dawn of the twenty-first century. The history of science and technology materials in manuscript include approximately 200 separate research collections, ranging from forty pieces up to hundreds of thousands of items per collection. Because research agendas change over the years, and because their size and depth make them worthy of repeated research investigations, the older collections at the Huntington maintain their value over time, while regular newer donations and purchases make it possible to expand the breadth and depth of the collections. The histories of astronomy, natural history, transportation, engineering, medicine, chemistry, and geology are all superbly represented.

A variety of topical areas are of particular strength, and the history of astronomy is perhaps the strongest area within the science collections. Manuscript material on this subject ranges from the ancient (a manuscript copy of Ptolemy's *Almagest* from 1279) to the modern (nearly a century's worth of Directors' Papers from nearby Mount Wilson Observatory). The Mount Wilson collection, heavily used by researchers in the history of astronomy and the history of science, comprises approximately 400,000 items, including correspondence, observing logbooks, and glass-plate negatives. The collection also includes correspondence with nearly every significant astronomer or observer of the late nineteenth and twentieth centuries.

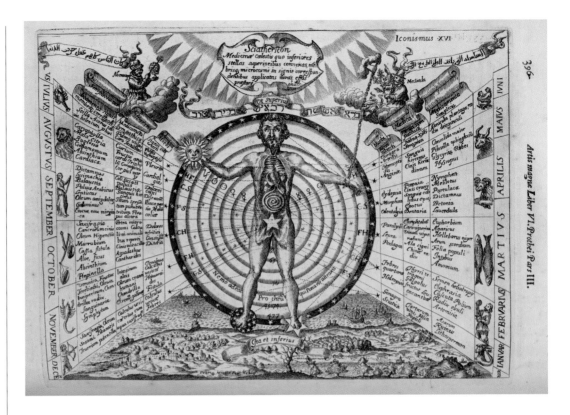

Printed items of outstanding rarity and provenance abound. The Huntington has a fine copy of Galileo's groundbreaking work *Sidereus nuncius*. Quickly published in a print run of 550 copies in March 1610 and widely distributed around Europe, the work served as the birth announcement of the telescope. Also in the collections is Edwin Hubble's copy of the 1566 second edition of Nicolaus Copernicus's *De revolutionibus orbium coelestium*; this book marked the first substantial effort to demonstrate that the earth revolved around the sun.

Natural history collections at the Huntington Library run the gamut from botany to ornithology to ichthyology. The Library's holding of printed works by Charles Darwin is unsurpassed in the United States, with a total of more than 1,000 different editions of Darwin's writings and more than 500 supporting volumes by Darwin's contemporaries and followers. These printed items are supplemented by 68 letters written by Darwin to a variety of his contemporaries, the last written just 24 days before his death.

One of the Library's treasures is the double-elephant folio of John James Audubon's *Birds of America* (1827–38) (illustrated on page 13). Audubon issued his masterwork in four very large volumes without text in order to avoid the expensive British copyright requirement that copies of all books published in England be placed in the numerous British libraries with copyright privileges. He later issued

the accompanying texts in a smaller and less expensive edition between 1831–39. Huntington purchased *Birds of America* as part of a lot that included another famous ornithology work, also by Audubon, entitled *Ornithological Biography, or An Account of the Habits of the Birds of the United States of America* (Edinburgh: Adam & Charles Black, 1831–39), which consisted of a five-volume set of smaller (imperial octavo) illustrations with woodcuts. Huntington paid $3,500 for these two sets in 1917. (A similar double-elephant set folio recently sold at auction for $8.8 million.)

The Library's important botanical works range from Theophrastus's 1483 *De historia et causis plantarum* to Linné's (Carl von Linnaeus's) *Hortus Cliffortianus* 1737 [1738], as well as the definitive tenth edition (1758) of Linné's ground-breaking *Systema naturae,* which lays out his system of binomial nomenclature. An extensive group of early herbals includes John Gerard's 1597 *Herball or Generall Historie of Plantes* and two copies of the revised 1633 edition (as well as the writings of Ray, Camerarius, Sprengel, and Schleiden). Zoological books include Robert Hooke's *Micrographia* (1665), Borelli's *De motu animalium* (1680–81), and Ledermueller's *Mikroskopische Gemueths-und Augen-Ergoetzung* (1760–63), with numerous works by Redi, Vallisnieri, Leeuwenhoek, Swammerdam, Joblot, Trembley, Lamarck, Cuvier, Baer, and Schwann, and a long run of the *Comptes rendus.*

ABOVE:
John Gerard
(1545–1612)
The Herball or Generall Historie of Plantes
[London: [Edm.] Bollifant for [Bonham Norton and] John Norton, 1597]
Source and date of acquisition unknown; RB 61709

As a rule, the Huntington has typically collected history of science materials for their research value, and not for their presence on lists of high spots in science. Still, the Library owns about two-thirds of the works published between 1455 and 1850 that are listed in Herbert McLean Evans's *Exhibition of First Editions of Epochal Achievements in the History of Science* (1934), Bern Dibner's *Heralds of Science* (1955, rev. 1980), and Harrison Horblit's *One Hundred Books Famous in Science* (1958).

The Huntington holds a number of manuscript items that are of value to scholars doing research in the field of natural history. Among these are the letters of George Suckley (1830–1869), who worked as a surgeon and naturalist for the Northern Pacific Railroad Expedition under Isaac Ingalls Stevens from 1853 to 1856; letters to Titian Ramsay Peale (1799–1885), an American naturalist and artist; and correspondence of Theodore S. Palmer (1868–1955), a California naturalist who led the first Death Valley Expedition in 1891. The William Jones Rhees Papers (approximately 4,700 items) offer information about the nation's natural history during the first half of the nineteenth century. Rhees served as chief clerk of the Smithsonian Institution, as chief executive officer under the Smithsonian's secretary, and later as its first archivist. Individuals involved in national politics, natural history, and science represented in this collection include Louis Agassiz, Alexander Dallas Bache, Salmon Portland Chase, Asa Gray, Hannibal Hamlin, John Tyndall, and Charles Wilkes.

Because of Huntington's role in creating the world's largest interurban transportation system in the first quarter of the twentieth century, the Library's transportation materials are particularly strong. These include Huntington's own papers concerning his business dealings in railroads, electric power, and real estate. As one of the top executives for the Southern Pacific Railroad, he kept an eye out for materials pertaining to British and American railroad history. As a result, several hundred U.S. and foreign railroads are represented within the manuscript, photographic, and printed collections, ranging from small and short-lived lines to others with long and proud histories. A rich visual record also exists within the Merrill Streamlined Railroad collection, which consists of many remarkable color images of "streamline" design railroad cars and engines from the twentieth century.

Maritime historian Jack Kemble's donation of 4,500 volumes in 1986 supplemented the Library's own holdings in early ocean travel and exploration and made the Huntington the foremost maritime library on the West Coast. Kemble's gift included many paintings of ships, a large collection of ephemera, and an endowment for lectures and purchases in the field of maritime history.

The collections also include important material about the history of engineering and technology. For instance, of the handful of maps that George Washington

BELOW:
Station view, Burlington line
Gift of Leslie O. Merrill,
Leslie O. Merrill;
Streamlined Railroad
Collection, 1976 and 1978

drew of his Mount Vernon property, the Huntington has the two best-known: a December 1793 map of the Five Farms that comprised Mount Vernon and a 1799 map showing the Dogue Farm at Mount Vernon. The manuscript collections also include another dozen hand-drawn surveys by Washington.

The engineering map and blueprint holdings, including railroad right-of-way plans, surveys of various national and foreign properties, engineering drawings of mining operations, and building plans (including several of Thomas Jefferson's surveys and plans for Monticello), comprise some 30,000 items. As a group of materials used for scholarship, these items show the evolution of surveying, the progression of railroad systems, and the numerous changes in engineering practice.

Chemistry is also well supported among the history of science materials. The Library has an extensive collection concerning chemistry during the eighteenth and early nineteenth centuries, with strong holdings of Lavoisier, Fourcroy, Guyton de Morveau, Kirwan, Nicholson, Davy, Chaptal, Berthollet, Berzelius, Macquer, Bergman, Liebig, Priestley, and many others, as well as a number of alchemical and early chemical works.

In geology, the Library has nearly all of the most important texts and geological maps from the period of the great revolution in the late eighteenth and early nineteenth centuries, including the essential works of Agassiz, Cuvier, Haüy, Hutton, Playfair, William Smith, Greenough, and Lyell, as well as of the pioneer geologists in the United States. In addition, it has extensive manuscript and printed materials on mining in California and other parts of the American West.

The history of medicine materials are also rich, encompassing a large collection received from the Los Angeles County Medical Association, along with the works collected by Huntington. Complementing the more than 530 printed works on medicine from before 1501 are approximately 6,500 rare books, historical reference works, pamphlets, and manuscripts.

Finally, the Huntington's history of mathematics collections include thirty-nine editions of Euclid's *Elements*, which codified two and a half centuries of labor on geometry into a single work. Printed in more than a thousand editions, this text makes Euclid in all probability the most successful textbook writer of all time.

LEFT:
George Washington
(1732–1799)
Autograph survey
map of Dogue Farm,
Mount Vernon,
20 September 1799
Purchaed as part of
the Grenville Kane
collection, 1913;
HM 5994

RIGHT:
Oliver Byrne
*The First Six Books of the
Elements of Euclid, in
Which Coloured Diagrams
and Symbols are Used
Instead of Letters for the
Greater Ease of Learners*
[London: William
Pickering, 1847]
Gift of B. F. Schlesinger,
1955; RB 302391

PTOLEMY'S *ALMAGEST*

This thirteenth-century vellum manuscript, a copy of Gerard of Cremona's translation of Ptolemy's great work on the earth-centered, or geocentric, universe, was produced by several monks at a monastery in Southern France. The geometrical diagrams are part of Ptolemy's discussion of the motion of a planet's epicycle.

ASTRONOMICUM CAESAREUM

This illustration of a dragon is typical of many of Apian's hand-colored illustrations from *Astronomicum Caesareum*, which has been called the most beautiful scientific book ever made. This clever work, which took Apian eight years to produce, is as much a scientific calculating instrument as it is a book. The pages are filled with carefully placed volvelles, or rotating paper disks, in as many as six layers. The volvelles, which could be used to calculate the positions of the Sun, Moon, or various planets, replaced a large amount of tabular data. They proved to be very accurate, yielding positions within one degree of the labor-intensive columns of numbers they replaced. In their elegant glory, the volvelles helped to "graphically display Ptolemaic astronomy in a fashion fit for a monarch's eyes," as historian Owen Gingerich has noted.

OVIEDO'S *HISTORIA GENERAL*

The Spanish explorer Fernández de Oviedo sailed to America in 1514 on the first of a number of journeys undertaken over three decades. An indefatigable chronicler of native life, he gave detailed descriptions of a great many products, activities, and practices. While confessing to having little skill as an artist, he presented important visual exotica to his fascinated European readers, including the pineapple (the first-known illustration of which is pictured here), canoe, hammock, manatee, and tobacco. His *Historia general* was probably written in Santo Domingo between 1539–46 and then completed in Spain in the following two years.

RIGHT:
Gonzalo Fernández de Oviedo y Valdés (d. 1557) "Historia general y natural de las Indias," 1539–48 Purchased from Maggs Brothers, 1926; HM 177

MEUNIER'S "HISTOIRE NATURELLE"

These exuberant and beautiful drawings are part of a longer set of bound manuscript illustrations done by Meunier and others, which include butterflies and other insects, crabs, shells, mammals, and reptiles. Victor Meunier worked squarely in the traditions of French natural history illustrators at the start of the nineteenth century. His exquisite realism and rich colors made him part of a school that included the French-trained Belgian botanical artist Pierre Joseph Redouté and a number of other highly skilled craftsmen. These artists knew a great deal about their subjects and produced work of exceptional technical skill.

LEFT:
Victor Meunier "Histoire naturelle, choix de dessins" Meunier, F. G. Pretre et Vaillant: [1820, n.p.] Purchased as part of the Robert Hoe library, 1911; HM 1552

Photography

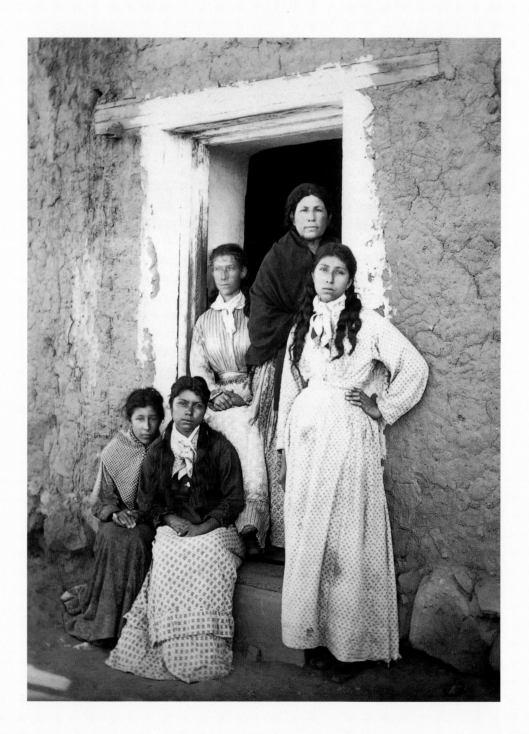

Eleven years after Henry Huntington's death, Librarian Leslie Bliss declined the offer of a large photography collection. "Photographs have so far not become an important field of collecting with us," Bliss wrote Los Angeles photographer C. C. Pierce. Some six decades and nearly half a million images later, the Library's photographic holdings rank as one of its great research strengths. What happened in the years between the librarian's pronouncement and today?

Bliss accurately portrayed the minor role visual imagery played in the institution's early days. On the rare occasion when Huntington purchased a photograph collection outright, as he did a few times in the early 1920s, it was the subject matter of the imagery, not an artist's name or any aesthetic criteria, that sealed the decision.

Few research libraries or museums of the era showed more than a passing interest in photography, and the Huntington was no exception. Photographs filled a purely documentary niche as graphic complements to printed materials. Picture collections were rarely purchased and more often acquired through gifts. The singular exception to this rule was the photographically illustrated book.

Some of photography's earliest and most significant masterworks first appeared in books. Images were pasted—or "tipped"—directly onto book pages until the early 1890s, when advances in printing obviated the need to use actual photographs in publications. *The Pencil of Nature* by British polymath William Henry Fox Talbot was the first of the genre. Talbot's experiments in optics and chemistry led him to create a paper negative—or calotype—from which multiple prints could be produced. He disseminated and popularized this landmark achievement in his 1844 volume.

On the other side of the Atlantic, George Fardon's *San Francisco Album* (1856) received acclaim as the first photographically illustrated book of an

American city. Fardon's static views of an orderly post–Gold Rush San Francisco offered a visual counterpoint to contemporary perceptions of the city as a place of mayhem and moral laxity.

Huntington's purchases of entire libraries ensured the inclusion of several superb photographically illustrated books. The broad geographical theme around which many of these acquisitions clustered prefigured the main subject of the Huntington's nascent photography collection: the American West. Successive librarians expanded upon Huntington's tentative forays into Western Americana. During the Great Depression, the institution hired its first (and only) full-time "field representative." Lindley Bynum had the enviable job of traveling around California ferreting out historical and rare material. In 1938 the Library acquired two of its most significant photography collections: the Charles C. Pierce collection and the Edward Weston collection.

Charles C. Pierce (1861–1946) was a Los Angeles photographer-entrepreneur who compiled a vast picture library depicting the history and explosive growth of Southern California and the greater Southwest. The Huntington purchased the Pierce archive of 10,000 photographs as a pictorial supplement to its growing

California materials. (It was this collection that Bliss had earlier refused.) Edward Weston (1886–1958) was a giant of modernist photography and the first photographer to receive a prestigious Guggenheim fellowship. The Guggenheim Foundation underwrote Weston's gift to the Huntington of 500 prints, most of them photographed during his grant period between 1937 and 1939. Whereas Weston was a famous artist whose images were prized for their masterful use of light, form, and space, Pierce was a businessman who freely copied the work of other photographers to augment his picture files. While the two collections had little in common aesthetically or otherwise, the Huntington received them both on the basis of their "western interest."

Bynum proved wildly successful as the Library's field representative, bringing in personal, family, and business papers along with albums, diaries, scrapbooks, business inventories, lantern slides, individual photographs (sometimes numbering in the thousands), and all sorts of other hard-to-categorize historical nuggets. The protocol was to separate photographs from their textual mates and remove them to an obscure corner of the building designated the "uncataloged stacks." To be sure, some photography purchases of note were made in a haphazard way. But the Huntington's photography collections grew more through accretion than conscious selection.

The 1970s witnessed a nationwide reappraisal of photography. Photography programs blossomed at universities across the country, published histories of the medium appeared, and exhibitions proliferated. Many libraries decided to re-examine what had been sitting on their shelves for decades. For the Huntington, the exercise proved revelatory. After years spent gathering Western Americana through books, manuscripts, and the sporadic purchase of photographs, it had a large, focused, and quite remarkable group of images. In the 1980s, the Huntington moved its photograph collections to a more suitable part of the building, installed a cold storage vault to preserve negatives, color images, and other fugitive materials, and hired the first curator of the photography collection. Photography had finally come into its own at the Huntington.

Huntington and Bliss could hardly have imagined the breadth and depth of the institution's photography holdings as they exist today. Nearly 500,000 images span the century from 1850 through 1950 and cover topics as disparate as the American Civil War, the building of the transcontinental railroad, and the "Grand Tours" of Europe. The collection's core strength remains the history and development of the American West. The archive encompasses both the single, startling image by the novice and the commercial photographer's life work—the known and the unknown, the pedestrian and the unique. What follows are some highlights from a collection that is by any measure extraordinary.

The James E. Taylor Scrapbook

Huntington's passion for the history of America included its bloodiest conflict, the Civil War—an interest that extended directly to photography. The scrapbook of James E. Taylor is a prime example of Huntington's enthusiasm. A skilled draftsman, Taylor served a successful wartime tenure as a "special artist" for *Leslie's Illustrated Magazine* before going on to a career as a painter of Civil War genre pictures. Taylor gathered images by renowned photographers George Barnard, Andrew Russell, Mathew Brady, Timothy O'Sullivan, and Alexander Gardner,

eventually compiling them in a three-volume scrapbook, along with newspaper clippings and drawings annotated with his personal observations. Many of these images of battlefields, regiments, and military personnel undoubtedly served as visual ready references for Taylor's later paintings. But the significance of the artifact is in its many rare photographs, its telling anecdotes, and its careful, even obsessive, arrangement. A page devoted to the assassination of Abraham Lincoln captures the spirit of Taylor's enterprise.

RIGHT:
James E. Taylor
(1839–1901)
"Abraham Lincoln"
page from James
Taylor Scrapbook
Photographs and
prints, n.d.
14 ½ x 11¼ in.;
photCL300, vol.1,
pg. 93

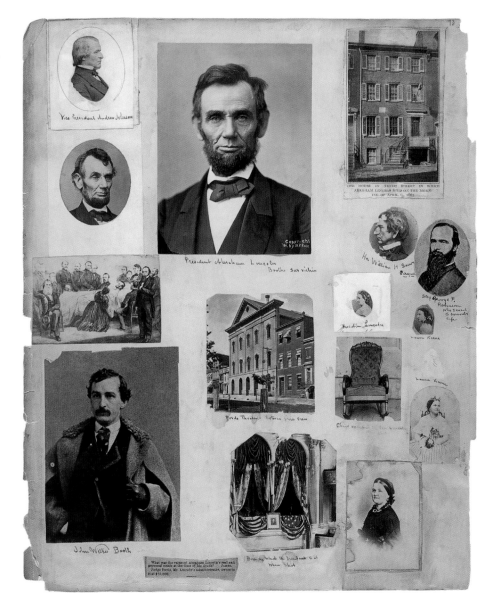

Types of Arabs. Constantinople.

Dancing Dervishes. Constantinople

Turkish Ladies. Constantinople.

Stamboul, from Galata.

LADY ANNA BRASSEY AND THE GRAND TOUR

A Victorian gentlewoman afflicted with an acute case of wanderlust, Lady Anna Brassey (1839–1887) satisfied her taste for travel aboard her yacht the *Sunbeam*. For a decade beginning in 1876, Brassey and her family circumnavigated the globe, collecting specimens to exhibit in their two English manor houses. Her published narratives of these trips made Brassey a celebrity, her books read by an entire generation of schoolchildren and their parents. Brassey's interests included photography, and though she dabbled a bit with the camera, she voraciously acquired images by professional photographers at every port of call. The approximately 6,000 pictures that Brassey later bound into seventy oversized volumes cover the period from the 1850s through the mid-1880s. Celebrated images from the studios of Eduoard Baldus in France, Giorgio Sommer in Italy, Pascal Sebah in Egypt, Dayal Deen in India, and Colonel Stuart Wortley in Britain, among many unattributed views, provide glimpses into a nineteenth-century world. Her selections reveal Lady Brassey's fascination with architecture, sea ports, and indigenous peoples. Brassey died from malarial fever in 1887 while on an extended voyage in the South Pacific. Huntington probably bought her albums in the early 1920s when the Brassey family began dispersing its holdings.

ABOVE:
Unattributed photographs from Lady Anna Brassey Album
"Types of Arabs, Constantinople"; "Turkish Ladies, Constantinople"; "Dancing Dervishes"; "Stamboul, from Galata," ca. 1870s
Albumen prints; single page: 17$\frac{1}{4}$ x 13 in.; photCL311, vol. 62, pg. 2–3

FRANCES BENJAMIN JOHNSTON

"Yes, I am the greatest woman photographer in the world," Frances Benjamin Johnston once remarked with characteristic swagger. That moxie led the accomplished photographer to Huntington's doorstep in 1924 with an offer to sell a collection she deemed "of utmost historic importance." A pioneering female photojournalist who later became renowned for her garden and architectural photography, Johnston operated a studio frequented by the social and political elite of the nation's capital. She convinced Huntington that her pictures of power brokers from the administrations of Harrison, Cleveland, McKinley, Roosevelt, and Taft were essential acquisitions. Illustrated here are two of Johnston's more compelling subjects. Her photograph of Lieutenant Colonel Theodore Roosevelt in August 1898 reveals the Rough Rider in his new uniform, fresh from its box and starched to perfection. Frances Hodgson Burnett, author of such childhood classics as *The Secret Garden* and *Little Lord Fauntleroy*, faces the camera with a fan insouciantly placed behind her head. Both these photographs reveal Johnston's trademark ability to capture the essence of her sitters.

THE WESTERN RAILS

The Huntington's photography collections reflect the empire that railroads built. Whether in iconic volumes such as Andrew J. Russell's *The Great West Illustrated* (1869) or Alexander Gardner's *Across the Continent on the Union Pacific Railroad* (1869), or in the picture files of the Los Angeles Railway and the Pacific Electric Railway, the Huntington holds vast pictorial resources related to western railroading. The stereographs shown at right offer the merest glimpse at these riches: a few examples of a nearly complete set of images taken in the 1860s by Alfred A. Hart to document the construction of the Central Pacific Railroad. When seen through a special viewer, these paired pictures take on a surreal three-dimensionality that gives the observer a "you are there" sensation.

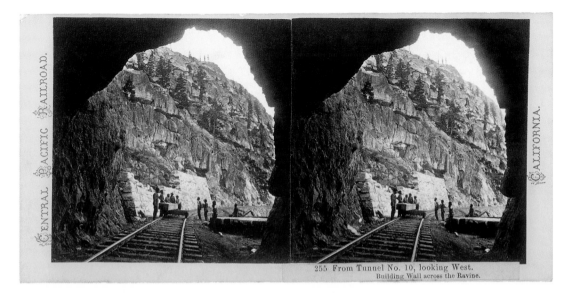

255 From Tunnel No. 10, looking West.
Building Wall across the Ravine.

TOP LEFT:
Alfred A. Hart
(1816–1908)
*From Tunnel No. 10,
looking West*,
ca. 1868
Albumen
stereograph,
3 ¼ x 6 ¼ in.;
photCL 184(255)

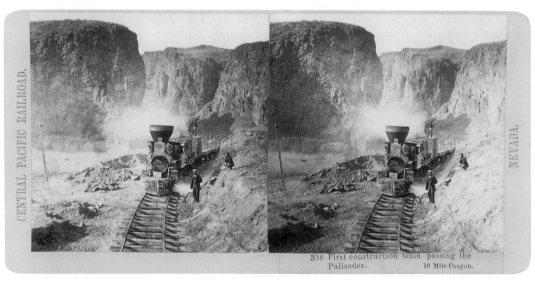

338 First construction train passing the
Palisades. 10 Mile Canyon.

LEFT:
*First construction
train passing the
Palisades. 10 Mile
Canyon*, December
1868
Albumen
stereograph,
3 ¼ x 6 ¼ in.;
photCL 184(338)

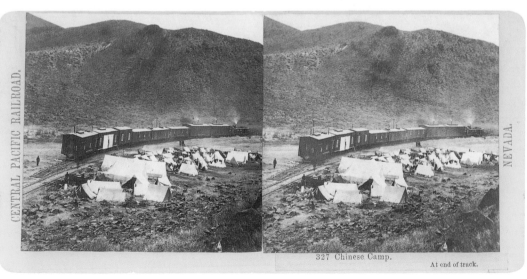

327 Chinese Camp. At end of track.

BOTTOM LEFT:
*Chinese Camp.
At end of track*,
ca. 1868
Albumen
stereograph,
3 ¼ x 6 ¼ in.;
photCL 184(327)

CARLETON E. WATKINS

Carleton E. Watkins became famous for his breathtaking images of Yosemite Valley—photographs that influenced President Abraham Lincoln to declare the region a national preserve in 1864. From the 1860s through the 1880s, the photographer traveled throughout California, Oregon, Nevada, Arizona, and beyond to create a remarkable body of work depicting the cities, commercial and agricultural enterprises, and landscapes of the American West. The Huntington owns a spectacular collection of Watkins photographs that can be traced back to the photographer's complex relationship with his powerful boyhood friend Collis P. Huntington. Watkins benefited from his acquaintance with Huntington, garnering assignments and performing all manner of photographic work for the Central and Southern Pacific Railroad corporations. At the center of the Library's holdings are four sumptuous albums of mammoth views bound in morocco leather. Institutional lore maintains that these were a gift from Watkins to his benefactor, a token of esteem for a man to whom the photographer owed his very career. The volumes—*The Central Pacific and Views Adjacent, Summits of the Sierras, Arizona and Views Adjacent to the Southern Pacific R.R.*, and *Photographic Views of Kern County*—make overt acknowledgment of the rail network as the source of Watkins's documentary sustenance. Over the years, the Library continued to add to its Watkins holdings through gift and purchase, making it one of the great repositories of the photographer's work.

BELOW:
Carleton E. Watkins
(1826–1916)
Round House, Yuma,
1880
Albumen print,
14 x 21 in.;
RB 137503 (1341)

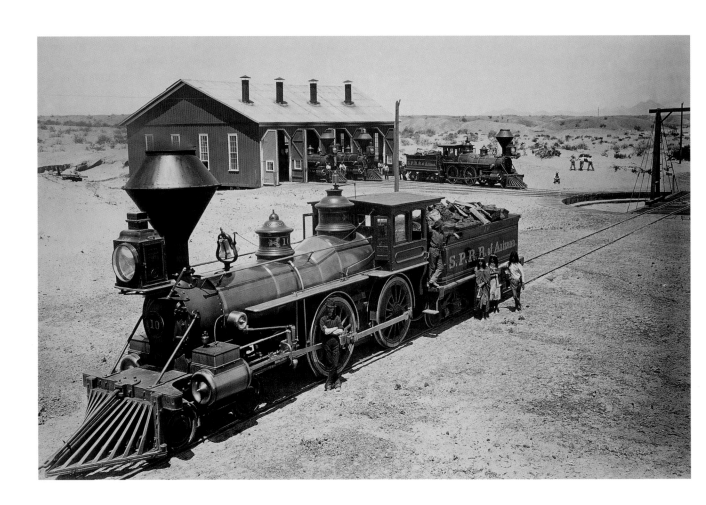

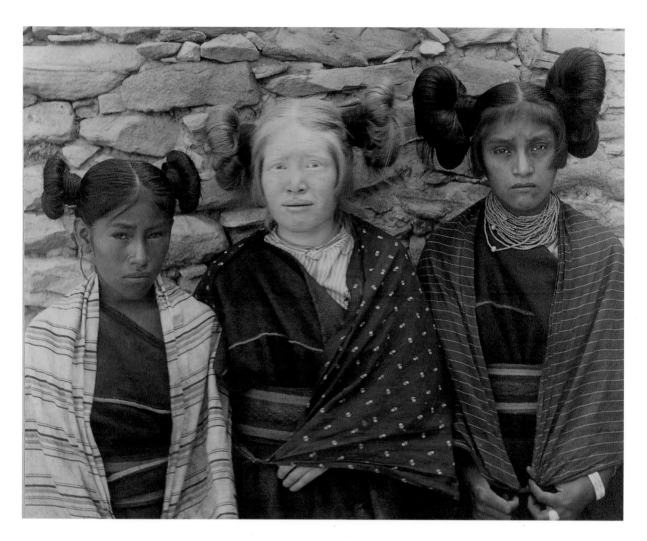

NATIVE AMERICAN PHOTOGRAPHY

Like many collectors of his generation, Huntington was captivated by Native American peoples—a fascination expressed through his purchase of several significant photography collections in the 1920s. His admiration for the images of Edward S. Curtis, Carl Moon, and Frederick Monsen led him to buy important works by all three artists. Monsen was a self-styled "ethnographer" who visited Southwestern tribes carrying a simple Kodak camera. He claimed his lack of fancy equipment relaxed his subjects, a group notoriously skittish after years of unpleasant interactions with photographers. The guarded looks of the three young Hopi women shown here, one of albino complexion, seem to belie Monsen's claim. Though he lost almost his entire archive in the San Francisco earthquake and fire of 1906, he managed to locate existing prints from which he made new negatives. He sold 373 of his finest pictures to Huntington in 1923. Later acquisitions of works by Adam Clark Vroman, Charles Fletcher Lummis, John Hillers, and William Soule further added to the Huntington's strong holdings in this field.

ABOVE:
Frederick Monsen
(1865–1929)
Hopi Girls, Oraibi, Arizona, ca. 1900
Toned gelatin silver print, 13 x 16 in.;
Monsen 172

SURVEYS OF THE AMERICAN WEST

Nowhere, it seems, did publishers, promoters, and touts embrace the use of photography more exuberantly than in the broad expanses of the American West. With the end of the Civil War came the golden age of the government survey. Each expedition leader employed photographers as he crisscrossed the West in search of optimal transportation routes, mineral and other natural resources, and opportunities to document indigenous peoples. Images by such notables as Timothy O'Sullivan, William Henry Jackson, John Hillers, and William Bell served a higher calling than mere records of geographical strata and landscape formation. They acted as windows through which to glimpse the nation's future. The Huntington's collection of western landscape photography contains an impressive number of images from this Great Survey period. Here Timothy O'Sullivan's photograph of ruins in New Mexico provides artful commentary on fleeting humanity set against nature's immutability.

RIGHT:
Timothy O'Sullivan
(1840–1882)
*Ancient Ruins in the Canon de Chelle,
N.M.*, 1873
Albumen print
Image: 10 ¾ x 8 in;
Mount: 19 ½ x
15 ½ in.; RB 278614,
plate 36

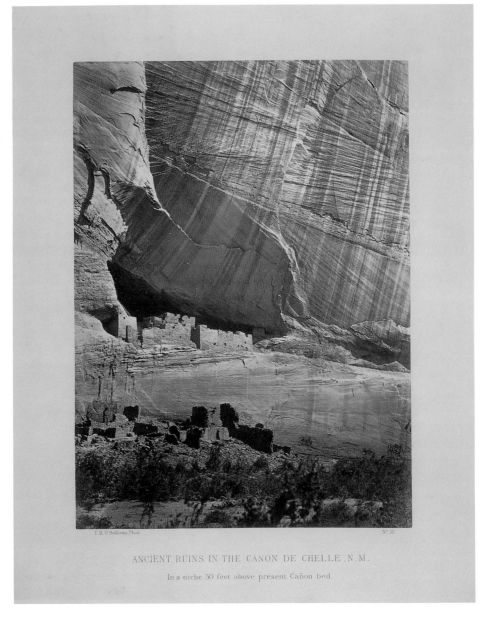

T. H. O'Sullivan Phot. N° 30

ANCIENT RUINS IN THE CANON DE CHELLE , N.M.

In a niche 50 feet above present Cañon bed.

TOP LEFT:
William M. Godfrey
(1825–1900)
Los Angeles, ca. 1862
Albumen print,
2 7/16 x 4 1/8 in.;
photCL 405 (48)

LEFT:
"Dick" Whittington
Photography
(fl. 1924–1983)
*Mayfair Tract,
Alhambra*, 1929
Modern gelatin
silver print from
original negative,
5 x 7 in.;
Whitt. 458/Neg. 349

LOS ANGELES AND SOUTHERN CALIFORNIA

Huntington believed Los Angeles was the city of the future, and he demonstrated this conviction through his prescient collecting of materials related to Southern California. The result of this acquisition policy—one that successive librarians enthusiastically continued—is a photograph collection unparalleled in its visual documentation of the explosive transition of greater Los Angeles from pastoral landscape to thriving metropolis. A rare image of the Civil War–era city by William M. Godfrey reveals a village of low-slung adobe buildings surrounded by farms and fields. This earliest extant photograph of Los Angeles gives not the slightest hint of the paved and landscaped place it would become. Some sixty years later, the "Dick" Whittington Studio captured a city reeling from a 1920s population explosion. The studio pictured nearly every major business and manufacturer in the city-on-the-make, including this group of satisfied developers admiring their latest project.

EDWARD WESTON

In the early 1940s, photographer Edward Weston selected and printed 500 of his masterworks for the Library. This gift was underwritten by the Guggenheim Foundation, which had sponsored Weston's photographic odyssey through California and the West in 1937 and 1938. The first photographer to receive a Guggenheim fellowship, Weston believed these two years to be the most productive and satisfying of his life. He wanted the work seen and he wanted it preserved, and he chose the Huntington to fulfill these goals. This extraordinary collection concentrates on the natural forms and resonant landscapes for which Weston became justly famous. "Anything that excites me for any reason, I will photograph," he wrote, "not searching for unusual subject matter, but making the commonplace unusual."

LEFT:
William Clarke
(1872–1953)
La Quinta,
ca. 1928
Modern gelatin
silver prints
from glass plate
negatives,
4 ¼ x 3 ¼ in.;
photCL 415 (279
and 359)

ARCHITECTURE

The built environment is one of many themes that emerge from the Huntington's photographic archive. Whether in nineteenth-century scenes of everyday residences or glossy images of newly constructed office buildings, the Huntington holds an extensive array of architectural views by both amateur and professional photographers. William Clarke captured the Mediterranean vogue of the 1920s and 1930s for *Architectural Digest*, depicting buildings and landscapes by some of Los Angeles's most distinguished architects and designers. Maynard L. Parker was a photographer whose pictures appeared in the pages of the magazine *House Beautiful*. A favorite of notable architects such as Frank Lloyd Wright and Aaron Green, Parker gained entrée into some of the most spectacular residences of his day, and his pictures reveal contemporary tastes and trends in decorating and in home and garden design.

LEFT:
Maynard L. Parker
(1900–1976)
Interior view of living room, Taliesin West, Arizona, 1946
Color transparency,
5 x 7 in.;
Maynard L. Parker
collection

Prints and Ephemera

HISTORICAL PRINT COLLECTION

Graphic images have long been valued for their ability to evoke the past, as they pictorially document key moments, personalities, and customs over time. In recent years, their role in scholarship has expanded, and printed images and other forms of visual material are now considered important historical documents in their own right. Historians and other scholars study their content, stylistic components, and the circumstances surrounding their creation, production, and consumption. Printed images record cultural perceptions, preoccupations, and change, helping to explain how and why we understand and remember the past in the ways that we do.

The Library's collection of nearly a quarter of a million historical, commercial, popular, and art history items documents significant events and figures of the United States and England and the ways in which American and British people have seen themselves from the sixteenth through the twentieth centuries. Featured less extensively are prints from other countries, which are collected only when they depict people or events that played a role in the development of Anglo-American history or culture.

Huntington initially focused on Old Master engravings, mezzotint portraits, and mini-print collections contained in extra-illustrated volumes. The accumulation of other types of prints and graphic images—and by extension the development of a print collection—occurred somewhat randomly during Huntington's lifetime and the half-century or so following his death. During that time, the Library made sporadic purchases and received donations, acquiring rare, valuable, and historically significant items such as the Kitto Bible, the Granger set of British portraits, and George Catlin's *North American Indian Portfolio*. Additionally, the acquisition of images of early British railroads, ballooning, and British estates and country houses complemented the institution's broader collecting goals of obtaining material pertaining to British and American literature, history, and culture. In contrast to the earlier tradition, a formal collection-development policy now governs the acquisition of historical prints.

This visual archive stimulates thought on social classes and on political, military, domestic, and religious life. Its wide range of subjects includes medicine, law, theater, architecture, recreation and leisure, family life, and commerce. The print collection—rich in portraiture and iconographic figures—represents the history and technical development of printmaking

LEFT:
T. van Buisen after
Gerard Hoet, n.d.
"Samson at his death
kills his enemies"
Engraving
Kitto Bible;
RB 49000, vol. 16, p. 2923

processes through the mid-twentieth century. Also included is a selection of tools and equipment involved in early printmaking, such as woodblocks, wood engravers' tools, copper and metal plates, and mezzotint rockers. The work of various well-known engravers and the output of key American, British, and European publishers is also available for study and exhibition.

ABOVE:
Copper Plate and Engraving of Roger Palmer, Earl of Castlemaine (1634–1705)
An Account of the Present War Between the Venetians and Turk, 1666; (Left) copper plate, Print Box 142; (Right) engraving, RB 273406 (frontispiece)

SATIRICAL PRINTS AND CARICATURES

Graphic humor can be found in a wide variety of formats, including illustrated newspapers and magazines, books and comic almanacs, drawings, and separately issued prints. On these next few pages, a selection of American and British social and political satires—compositions meant to hold up human vice or folly—are presented. Satires often represent their key players in caricature style, where the peculiarities of the person are exaggerated in order to evoke a calculated response. As elements of larger compositions or as the single element of an individual portrait, caricatures typically convey an underlying judgment on their subjects.

Produced in a timely manner, and accessible even to the illiterate, the separately issued American political print highlighted important messages symbolically, leaving a rich visual testimony of political thought from Colonial times through the late nineteenth century. Generally speaking, their creators (most of whom worked in the Northeast, especially New York) were not typically aligned with political parties. Prints produced by dealers and merchant lithographers were viewed as marketable commodities and produced accordingly. This image, issued during the Civil War, depicts then-presidential hopeful George McClellan acting as an intermediary between Abraham Lincoln and Jefferson Davis, President of the Confederacy. Arguing over the future of the United States, Lincoln and Davis hold tightly to their respective sections of a map.

THE TRUE ISSUE OR "THATS WHATS THE MATTER".

LEFT:
Currier and Ives
"The True Issue or 'Thats Whats the Matter'" [*sic*]
Lithograph, 1864;
American Political Cartoon collection

Contrasting virtue and vice, reward and punishment, painter/engraver William Hogarth's satirical work reflects his interest in social reform; he used prints as a vehicle for conveying moral standards to the largest audience possible. Visual puns, meaningful juxtapositions of objects, elaboration of detail, and the unexpected—all figure in Hogarth's perception of a noisy, crowded, and corrupt eighteenth-century London and signal the choices he believed his contemporaries should make. His frequently sensational images are packed with meaning and must be carefully decoded—a practice easy for those familiar with conventions of the day. *A Rake's Progress*, like many other examples of Hogarth's narrative work, explores the consequences of wanton behavior, vanity, and affectations.

Human excess was a common theme among satirical printmakers. The vagaries of fashion, the overindulgence in rich food, and the questionable private and public behavior of prominent British figures were subjects near and dear to caricaturists' hearts. Such themes were portrayed with aplomb by George Cruikshank, James Gillray (see "The Gout," next page), Thomas Rowlandson, and a large number of other, less well-known British satirists, evoking responses that ranged from amusement to outrage. The Library's sizable collection of nearly 10,000 unique British satirical prints contributes to an understanding of contemporary social and political attitudes, values, and lifestyles.

The GOUT.

Pub.d May 14.th 1799. by H. Humphry
27 S.t James's Street.

LEFT:
James Gillray
The Gout
Etching, 1799
BM 9448
RB 225625 1 454

Caricatures of notable Victorian and Edwardian personalities, such as this evocative interpretation of Scottish author and social critic Thomas Carlyle, were included weekly throughout most of the run of the British society magazine *Vanity Fair* (1868–1913). The Huntington's collection of 1,620 caricatures (nearly three-fourths of the total number produced) illustrates the ways in which regular contributors Carlo Pellegrini (pen name: "Ape"), Sir Leslie Ward ("Spy"), and others were able to seize the essential traits of their subjects and exaggerate them, offering penetrating insights into the character of prominent politicians, nobility, doctors, clergy, and literati.

LEFT:
Thomas Carlyle, "Men of the Day" No. 12 (22 October 1870)
Chromolithograph
"Ape" (Carlo Pellegrini)
Vanity Fair, 1870
Vanity Fair collection, RB 301516, p. 103

Extra-Illustrated Books

Extra-illustrating books was a popular pastime among the wealthy in Great Britain and the United States from the mid-eighteenth through the early twentieth centuries. Hobbyists would gather works of art on paper, particularly prints, but also drawings and occasionally photographs, with the aim of providing "extra" illustrations to a text—typically a biography, work of history, volume of Shakespeare, or the Bible. After removing the book from its original binding, enthusiasts would organize the images they had collected according to the thematic structure dictated by the work, mount them, and rebind the whole, thus creating an artifact that, owing to its new size, encompassed several volumes. The embellishing of a work that originally contained comparatively little or no pictorial content resulted in multiple, sometimes competing, interpretations of literary, religious, and other subjects. Several hundred thousand images are available through more than 1,000 extra-illustrated sets in the Library.

Among the Huntington's most important extra-illustrated sets is the massive Kitto Bible, organized by James Gibbs in the early nineteenth century, which contains some 30,000 prints illustrating the Old and New Testaments.

Theater history, another area of strong holdings, is brilliantly illuminated by sets such as Thomas Turner's *The Dramatic Works of Shakespeare revised by George Steevens* [1802], containing 3,000 portraits, plates, and playbills of various performances, along with more than 740 original drawings—many by important British artists. The work is a convenient compendium of nearly all the book-sized printed illustrations to Shakespeare that had appeared by the early nineteenth century and a large portion of the related preparatory drawings.

LEFT:
Stow after Rigaud, 1797
"Romeo, Juliet, and Nurse"
*The Dramatic Works of Shakespeare
revised by George Steevens*
[1802]; RB 181067 xli 95

PRINTS AND HISTORICAL UNDERSTANDING

Prints idealize, persuade, and inform, carrying assumptions of not only their creators but of society at large. Beyond the obvious visual appeal, a print functions in a variety of ways. It can also be understood as a framework for telling stories of lasting significance, as a form of propaganda, and as a vehicle for reinforcing myths. Then, too, a print may even contribute to one's sense of cultural identity and belonging. Since historical depictions have the power to shape viewers' understanding of the world, the widespread dissemination of these images has been useful to many groups past and present as affirmation of dominant values and institutions. Through repeated exposure to visual representations of people and events (and, conversely, the omission of others, and/or the marginalization of issues such as sexism or class struggle), we understand and remember certain aspects of the past. The power of the visual to shape, reinforce, or even alter our understandings can hardly be overstated.

Prints have played a significant role in mythologizing the past. In his memoirs, John Smith remembered Pocahontas as a bold, spirited preteen as well as a dignified, Anglicized woman who was later received at the Court of St. James. Yet it was the dramatic moment of Smith's alleged rescue by Pocahontas that was seized upon and replayed throughout the nineteenth century by authors and artists, transforming the friendship between Smith and Pocahontas into a love affair. Engraver Alonzo Chappel, for example, was misleading in his depiction of their relationship and the actual danger to Smith. The popularity of such romanticized prints undercut other aspects of Pocahontas, including her nobility and pedigree.

RIGHT:
Alonzo Chappel,
1866
"Pocahontas
Saving the Life of
Capt. John Smith"
Engraving;
Print Box 600C/9

Visual representations of national leaders both reflect and contribute to popular feeling. Apotheosis scenes such as this one, in which Washington ascends to heaven escorted by "Virtues," leaving behind thirteen weeping women who represent the "Orphan States," were common during the nineteenth century; such imagery and its frequent reprinting in nineteenth- and twentieth-century textbooks and other media illuminates the process by which Washington entered our national consciousness.

The mid–nineteenth century image below, published by the successful lithographic firm Currier and Ives, informs viewers that the California coast is ostensibly a lush, tropical paradise. Whether or not the artist had ever visited California is a moot point; the overriding commercial consideration—the creation and production of a sumptuous image—prevailed over fact and accuracy.

ABOVE:
H. Weishaupt after Samuel Moore, n.d.
"Apotheosis of Washington,"
Lithograph; Print Box 585/13

BELOW:
Currier and Ives, n.d.
"On the Coast of California"
Hand-colored lithograph; Print Box 1011/28

PRINTED EPHEMERA

In general, ephemera can be understood as the transient documents of everyday life. Frequently visually compelling, they captivate through their appearance and potential meaning. The Library's extensive ephemera collections are rich and varied in format. As source material, promotional literature, broadsides, postcards, pamphlets, labels, and theater programs, for example, are useful to scholars in fields as diverse as social, business, political, and cultural history, providing evidence for their theories and arguments. Ephemera are reflective of our ever-changing cultural self-perceptions and concerns.

Ephemera holdings include items with broad or national interest; especially noteworthy are the Korzenik Art Education Ephemera collection; business trade cards; World War I, work-incentive, and public-health posters; transportation ephemera, including the Kemble Maritime and Merrill Streamlined Railroad collections; and American political campaign material. Items of regional interest include citrus labels, California promotional literature, and materials for Los Angeles–area women's clubs and Southern California theater and cultural events.

In times of crisis, the U.S. Government Printing Office issued myriad printed ephemeral pieces. Posters and pamphlets, for example, were thought to be useful in edifying the public during World War II. The small poster (*This is a V Home*) was meant to encourage civilian support of the war effort by listing (and displaying

prominently) the ways in which one might contribute on the home-front. In spare, somewhat humorous terms and images, soldiers were instructed via small pamphlets about ways they could avoid contracting or spreading malaria. *This is Ann* was illustrated by Theodore Geisel before he achieved fame as the children's author/illustrator Dr. Seuss.

LEFT AND RIGHT:
Theodore Geisel
"This is Ann"
U.S. Government Printing Office,
Navy Department, ca. 1943

POSTERS

The Huntington's poster collections bear witness to the birth of modern advertising through bold graphic imagery dating from the late nineteenth through mid-twentieth centuries. Diverse subject matter and imagery form a compendium of examples that were meant to sell products, ideas, and attitudes. Book and magazine promotion, World War I, work-incentive, transportation, and public-health posters trace changes in popular aesthetics, printing technology, and sociopolitical concerns in America throughout several eras.

Posters were a key element in the government's campaign to unify the United States during World War I. Powerful imagery, often depicting likable, decent, and noble Americans—or, conversely, evil enemy archetypes—simplified the messages symbolically and heightened the sense of viewer involvement. This aided in recruitment efforts, the creation of civic and financial support, and other behaviors that were crucial to the war effort.

By the mid-1890s, posters were regularly used by the American publishing trade to enhance book and magazine sales. The Art Nouveau example (upper right, next page) by prolific poster artist Will Bradley (1868–1962), frequently referred to as "the dean of design," depicts an enamored faun and nymph. The poster promoted Tom Hall's book of verse *When Hearts Are Trumps* (1894).

The work-incentive poster, which was prominent in the United States during the 1920s, took the idea of the poster in an entirely new direction. Series of posters were developed with the intention of creating, modifying, or changing attitudes and work practices of employees in industry and commerce, discouraging absenteeism, rudeness, inattentiveness, and laziness. The posters were sold and used in America, Canada, and England.

OPPOSITE, TOP LEFT:
W. A. Rogers
"Only the Navy Can
Stop This"
World War I poster,
ca. 1915–17;
World War I Poster
collection, S-6

TOP RIGHT:
Will Bradley
"When Hearts Are
Trumps"
Book poster, 1894;
Book and Magazine
Poster collection

BOTTOM LEFT:
W. F. Elmes
"Look Out!"
Charles Mather
Company
Color lithographic
poster, 1929;
Work-Incentive
Poster collection

BOTTOM RIGHT:
"Malaria Knocks
You Flat"
U.S. Government
Printing Office, 1948

ONLY THE NAVY CAN STOP THIS

WHEN HEARTS ARE TRUMPS BY TOM HALL

LOOK OUT!

MALARIA

Knocks you flat

KEEP COVERED USE YOUR REPELLENT

KORZENIK ART EDUCATION COLLECTION

The Diana Korzenik Art Education Ephemera collection includes items as diverse as tracing books and slates, drawing cards, geometric blocks, picture study examples, crayons, and paint sets. More than 1,000 artifacts and nearly 500 books give insight into the ways society has valued art instruction over time, as well as the multitude of means educators and businessmen have used to convey principles of art to children. Past trends and developments in the teaching of art, especially the underlying rationales for such instruction, are revealed through the material itself.

The Korzenik collection demonstrates the evolution from nineteenth-century drawing books, which presented highly structured exercises, to twentieth-century art learning materials promoting developmentally appropriate, sequential methods that enhance self-expression and spontaneity.

Throughout its long history, the Chautauqua Industrial Art Desk (also known as the Chautauqua Combination Drawing Board and Writing Desk) was promoted by its manufacturer and distributor Lewis E. Myers & Co. as a useful tool for home teaching. Produced between the late 1880s and the mid-1920s, it was designed to encourage a child's self-direction, initiative, originality, and vocational interest. Fastened to the wall or simply placed on a table, the desk was reversible, featuring wooden and chalkboard surfaces. A movable paper scroll presented the child with a series of basic lessons in many areas, including drawing, handwriting, mathematics, geography, color treatment, commercial and artistic lettering, shorthand, and bookkeeping. The art lessons in particular required the child to imitate the tone, color, and pen strokes found on the scroll.

RIGHT:
Chautauqua
Combination
Drawing Board and
Writing Desk
Lewis E. Myers Co.,
1895;
Korzenik collection,
Box 14

ABOVE:
"California for the Settler"
Promotional pamphlet
[San Francisco: Southern
Pacific Co., 1922];
RB 194725

PROMOTIONAL LITERATURE: PROMOTING PLACE

Through ebullient descriptions and enticing images that symbolized Western health and abundance, promotional pamphlets encouraged Western migration and settlement during the late nineteenth and early twentieth centuries. The material was produced by local and state chambers of commerce, boards of agriculture, railroad companies, immigration societies, and many other organizations that stood to benefit from further settlement of any given "land of opportunity." In less-than-subtle ways, posters and broadsides, maps, booklets, newspaper and magazine articles, and cartoons suggested that barren areas were richer in cultural, commercial, and agricultural advantages than they actually were. As historical evidence, they are not so much faithful records of the history of regional development as they are indicative of what promoters hoped would materialize in an area. Then, too, some of the hyperbole can be understood as fabrication meant for financial return and little else. In either case, a full and accurate portrayal of the life settlers might find (including the dangers or difficulties of farming in a semiarid environment) was seldom offered.

Although we will never know the actual impact of this literature, of which millions of copies circulated in the United States and Europe during the West's boom years (from the 1870s to the 1930s), scholars believe that it played a significant role in convincing potential migrants to make the move. The material is suggestive of the ways in which popular perceptions of place are created, transmitted, and sustained over time.

LEFT:
"Ventura County:
Opportunity in
California"
[Ventura, California:
Ventura County and
Ventura County Chamber
of Commerce, ca. 1923]
Promotional pamphlet;
California Promotional
Literature collection

CITRUS LABELS: PROMOTING PRODUCT AND PLACE

Like promotional literature, citrus labels contributed to a sense of place in the American imagination during the time of their use, roughly the 1880s to the 1940s. Affixed to wooden crates and seen by consumers and wholesalers across the nation, these 11 x 10 inch "mini-posters" were designed initially to identify and distinguish various citrus growers' products at market and, later, to distinguish them in huge warehouses. Labels necessarily vied for attention. Often the brands that were easiest to remember were the ones that were purchased.

Labels also had other functions, particularly for Southern California growers. The success of a grower in the as-yet sparsely populated region of the state was contingent upon development of the land. In order to help develop the infrastructure—add more railroad lines, create irrigation systems—growers coaxed settlers to the state. Although subject matter, theme, and design varied greatly from label to label, a large proportion stressed the most positive and appealing attributes of the state, liberally depicting scenes of lush, even exotic vegetation, sunny beaches, and clear blue skies. They also suggested health, sensuality, youth, and vigor. During the first few decades of the twentieth century, a collective understanding of California began to develop across the nation, an understanding that has been reinforced by visual material up through and including the present. The labels shown here indicate the ways California has been romanticized, even mythologized, by citrus label imagery.

The Sunnycal label depicts California as a lush environment, a place where trees, plants and sunshine are in abundance. Through the eyes of potential settlers, attributes like fecundity, warmth, activity, leisure, and distinctiveness came to be associated with Southern California.

In linking citrus fruit with the wide-open spaces, aridity, and vitality of Southern California, labels elevated the state—or the promise of the state—to almost mythic proportions.

By the 1920s, labels such as "Miracle" Brand took as their themes unusual, even exotic, design elements such as the special powers of a genie depicted on this label. These elements—and the brand names that went with them—reinforced and elaborated the theme of California as an extraordinary place.

BELOW:
"Sunnycal Brand"
Irwindale Citrus Association
Irwindale, California, n.d.
Citrus label;
Citrus label collection, S6-31

BOTTOM:
"Miracle Brand"
[Bradford Bros. Inc. Placentia, California, 1920s]
Citrus label;
Citrus label collection, M-41

Maps

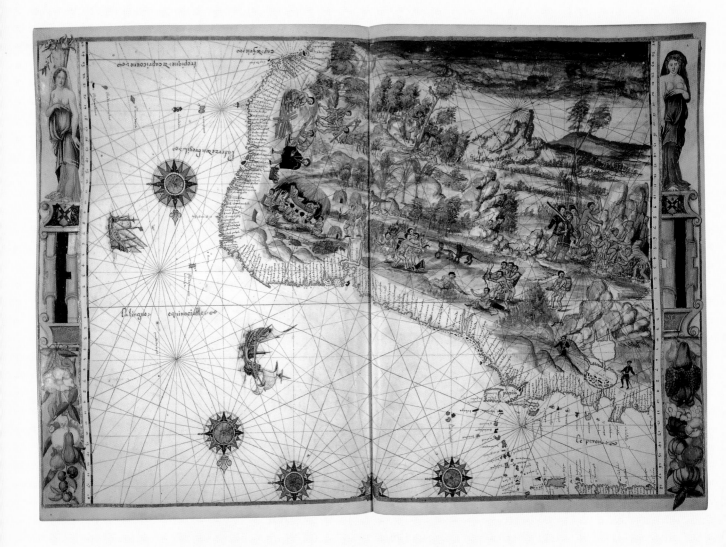

While collecting cartography was not his highest priority, Huntington did recognize the significance of maps to the study of history. His en bloc acquisition of the Church and Bridgewater libraries in 1911 and 1917, with their rich variety of maps and atlases, confirmed early on his understanding of the importance of the cartographic record in documenting European exploration, colonial expansion, and British and American history. Huntington and his staff later reaffirmed the integral role maps played in historical research by making a concerted effort to acquire major cartographic collections, particularly the Charles Gunther collection from the Chicago Historical Society and two Museum Bookstore catalogs of 1,800 early American maps. Nautical atlases from the library of Sir Thomas Phillipps and major archives such as the Robert Alonzo Brock collection of Virginiana and the English Stowe papers brought valuable cartographic materials. In 1928 Colonel Lawrence Martin, Chief of the Library of Congress's Division of Maps, was asked by the Library to review what Huntington had accumulated. He wrote enthusiastically: "The Huntington Library has a splendid map collection and the world will wear a path to your door."

MANUSCRIPT MAPS

In this collection that Huntington rapidly amassed some manuscript maps came in as incidental illustrations in manuscript books, a prime example being the world map in Ranulf Higden's "Polychronicon" of the 1340s. Others, such as the sixteenth- and seventeenth-century "portolan" or nautical atlases and charts, were purposefully acquired, largely in two great and expensive spasms of buying in 1917 and 1924. Whether valued by Huntington for their beauty, their importance in the history of cartography and exploration, or both, the result is one of the more distinguished collections of such material anywhere. Included in Huntington's purchases were several particularly important items, such as the "King/Hamy" world chart and the "Vallard" and Vaz Dourado atlases. Taken together, the manuscript maps from Higden in the fourteenth century to those of the early seventeenth century illustrate the complex set of transitions taking place in that period—from largely ancient (Ptolemaic) and medieval (both patristic and utilitarian) conceptions of the world and man's place in it, to other conceptions informed by knowledge gained from experience and observation, especially as Europe expanded into parts of the world unknown or only dimly perceived by classical culture and its medieval successors.

FAR LEFT:
"Vallard Atlas"
Map of Brazil,
manuscript
[Dieppe, ca. 1547]
Purchased from
A. S. W. Rosenbach,
1924; HM 29(11)

From the late sixteenth century, with the increasing domination of printed maps for most general purposes, manuscript maps tended to retreat into more or less specialized niches, where their restricted circulation was an asset. These are represented in part in the Huntington's collection of *derroteros*, atlases of detailed navigational charts and sailing instructions for the coasts of the Americas. These maps were often treated as state secrets and were meant only for the use of Spanish pilots. They facilitated safe navigation by showing danger points, assisting in the correct fixing of a vessel's position when entering port or sailing along a coast, and indicating the preferred watering places, harbor entrances, and anchorages. *Derroteros* for the west coast of the Americas were kept in manuscript and copied as needed for Spanish pilots. That way, they could be updated quickly and kept under far tighter control than if they had been printed. Despite Spain's best efforts, however, a small number of copies fell into unfriendly hands.

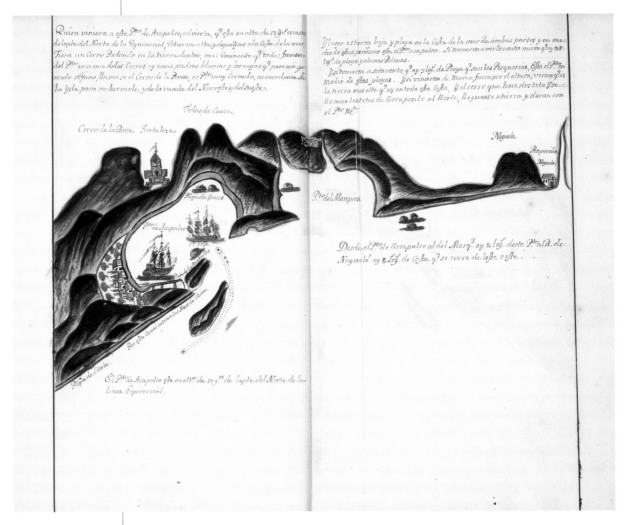

Other manuscripts were generated for military purposes, detailing harbors and coastlines, recording military operations, and illustrating the disposition of potential enemies, whether indigenous or European. In most cases, the target audiences were small and carefully chosen. The Huntington has a significant sampling of such maps dating as far back as the seventeenth century.

The Library has continued to add to its holdings of manuscript maps, with the focus narrowing first to Mexico and North America, then in particular to what would become the American West, and finally to Southern California. Spanish charts by Fernando Consag, Felipe Bauzá, and Miguel Costansó trace the maritime exploration and settlement of the Pacific coastline of North America, while contemporary maps by such men as Nicolás de Lafora and Juan Pedro Walker help to reconstruct the process by which geographical images brought into focus the interior of the American Southwest and northwestern Mexico along with snapshots of the distribution of the region's native peoples.

A large collection of more recent maps reflects another prime use of non-printed material. As the United States spread into and settled the Far West, there was an urgent need to divide up and define the boundaries of the newly acquired land and to lay out the new towns that were blossoming to accommodate the flood of immigrants. The earliest phases of the close relationship between the Southern California economy and real estate development are reflected at the Library in thousands of survey maps, many of them in large collections such as the Solano-Reeve and the Southern Pacific, as well as in Huntington's own business papers. Locally, U.S. Army Lieutenant E. O. C. Ord helped to initiate the process when he subdivided the public lands of Los Angeles in 1849 so that they could be converted into revenue for the city, a source of potential wealth for land developers, and eventually into homes for the repeated waves of people that would arrive in Southern California from that day to this. Ord was hired to provide a detailed map of the heart of the pueblo lands, depicting not only the topography, existing roads, cultivated fields, and buildings, but also laying out the future network of streets and subdividing the vacant land to be sold.

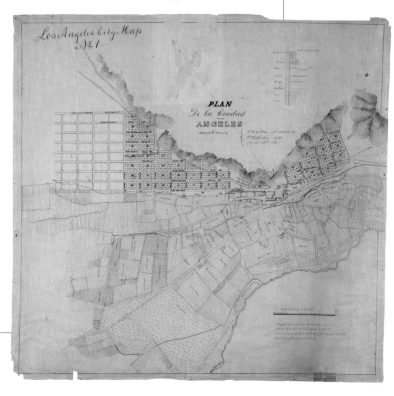

HIGDEN'S *POLYCHRONICON*

In the fourteenth century, the English Benedictine monk Ranulf Higden wrote a history of the world from Creation to his own times. This text was still popular in 1482, when it was first printed by William Caxton. To set the scene for the historical events at the core of the work, Higden began with a detailed description of world geography, based largely on Roman and early Christian sources and illustrated by a map made expressly to reflect and visually structure the information in the text. As a map in the modern sense, it was already consciously archaic when it was made, reflecting none of the information available at the time from the works of Marco Polo and other travelers to Asia and little of the spatial accuracy of contemporary *portolan* charts. Rather, it parallels diagrammatic maps of largely Roman and patristic derivation,

whose main purposes were religious, philosophical, and didactic. The world is represented as a flat disk with east at the top, the place where Adam and Eve had their fateful encounter with the Serpent and the Tree of Knowledge. The map is centered roughly on Jerusalem, with Asia and the Red Sea at the top, and Africa on the lower right facing Europe to the left across a vertical Mediterranean. The map supports the general aim of the work—instructing the faithful in the Christian view of history—by visually organizing the necessary geographical knowledge as an aid to memory. The oval shape has been explained variously as an accommodation of the traditional world disk to the rectangular page or as a symbol of the outline of Noah's ark, bearing humankind on its journey through history.

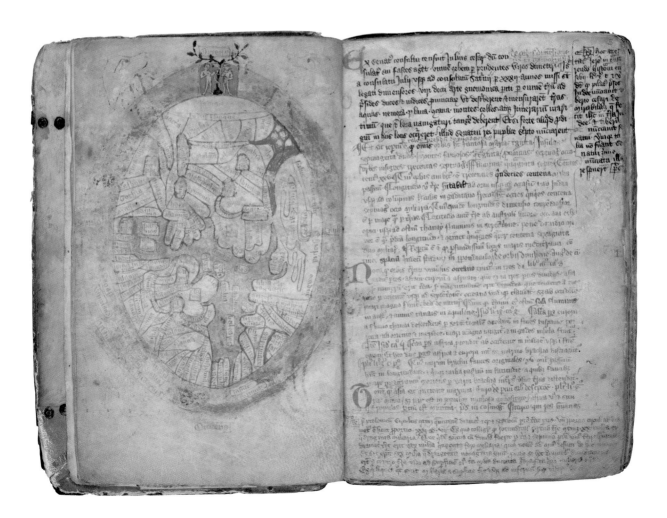

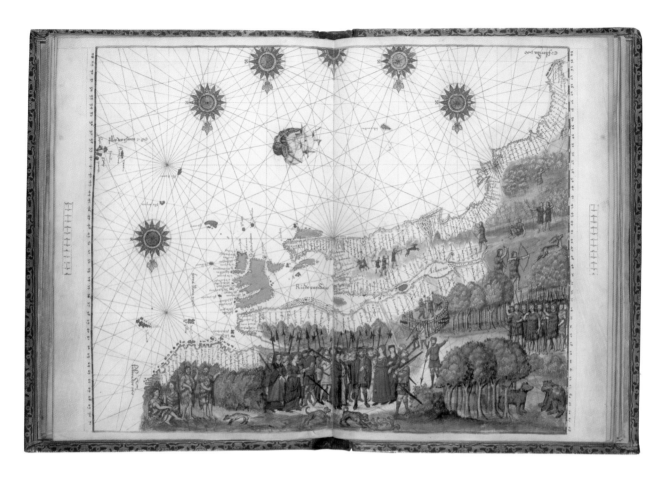

THE "VALLARD ATLAS"

The "Vallard Atlas" was created no later than 1547, apparently for a wealthy merchant named Nicholas Vallard by an anonymous, possibly Portuguese, mapmaker. It is one of the most visually impressive examples of the Norman or "Dieppe" school of cartography. These luxurious maps and atlases first appeared in the 1530s at a time of active participation by Breton and Norman sea captains in overseas exploration and attempts at colonization. Their interests were shared by the wealthy and powerful in France and elsewhere, and it was for such influential, sometimes royal, patrons that most of the early products of the Dieppe school were intended.

In the map shown here (in which south faces up) the prime focus of the illustration is on the European settlers, both men and women, apparently members of the abortive colony established at France-Roy under the sieur de Roberval in 1542–43. Both Europeans and natives are conspicuously armed, with the exception of the two native couples to the left on the Labrador coast, while the stockade representing France-Roy sports four cannon. Here, at least, is a connection to the larger reality of the long history to come of problematic relations between European colonists and the indigenous peoples of North America.

ABOVE:
"Vallard Atlas"
Map of northeastern North America
Purchased from
A. S. W. Rosenbach, 1924; HM 29(9)

"KING/HAMY" WORLD CHART

This world chart is based largely on a Portuguese prototype. The Mediterranean Basin reflects the standard *portolan* tradition, while Asia is still fundamentally Ptolemaic in its outlines. The chart also includes legendary elements such as Prester John and the Mountains of the Moon as the sources of the Nile, along with information from Marco Polo (the city of Quinsay) and other more recent travelers. At the same time, it indicates an awareness of the commercial and strategic importance of the ports of Calicut and Malacca. Change is more obvious in the trace of the east coast of Africa, which is well-defined, reflecting the direct experience of Portuguese fleets through the voyage of Diogo Dias in 1500–1501. The entire coastline of Africa has a fully developed complement of more than 150 place names, and is remarkably accurate in outline for so early a date.

In the newly discovered Americas, where there were no existing authoritative descriptions, the information is almost exclusively based on the reports and perhaps the sketch maps of explorers. In particular, the outline of South America directly reflects the recent voyages of Ojeda and the Portuguese on which Amerigo Vespucci sailed. The Caribbean area includes one of the first depictions of Cuba as an island rather than a peninsula of the Asian mainland. Indeed, the map is one of the first to clearly show the Americas as distinct from Asia. To the north are the recent discoveries in Labrador or Newfoundland by the Corte-Real brothers in 1500–1502.

Finally, the "King/Hamy" map is one of the earliest attempts to modify the traditional nautical chart for use with the vital innovations taking place in navigational techniques. This map—to facilitate latitude sailing and celestial navigation, the keys to open ocean sailing—is one of the very first such charts to have a latitude scale, apparently positioned to mark the 1494 Line of Demarcation, which assigned spheres of interest to Portugal and Spain. The era was still one of experimentation and often unsuccessful efforts to reconcile frequently contradictory information, as can be seen in the abrupt break in the Brazilian coastline and especially in the temporary expedient of two different equators, one for the Atlantic and another for the Indian Ocean. A political subtext is also perhaps suggested by the placement of Newfoundland on the eastern, Portuguese side of the Demarcation Line.

VAZ DOURADO'S PORTOLAN ATLAS

Fernão Vaz Dourado was born in Goa, India, around 1520, the son of a Portuguese official and, in all likelihood, an Indian mother. After traveling throughout India and across the Bay of Bengal in his youth as a soldier and navigator, he settled down in Goa again, becoming one of the foremost Portuguese cartographers of his age and exercising a significant influence on European geographical conceptions, most directly with regard to the shape of Japan. Six of his atlases survive, four of them made in India, including the one owned by the Huntington. Renowned particularly for their fine draftsmanship and the beauty of their decoration, they form a body of work without parallel in the sixteenth century.

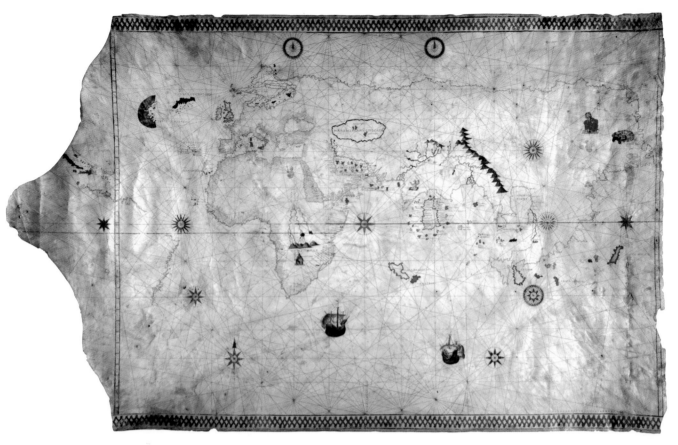

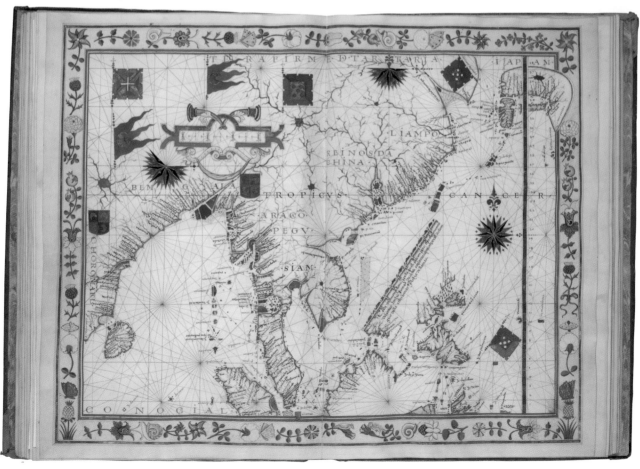

PRINTED MAPS

The pre-1800 printed European maps in the Library document the development of geographic knowledge and the evolution of scientific cartography. The English material is the richest and most varied, illustrating maritime exploration, New World settlement, and scientific surveys as well as English counties, cities, and roads. Examples are Christopher Saxton's magnificent *Atlas of the Counties of England & Wales* (ca. 1590), presented to the first Earl of Bridgewater; John Rocque's detailed *An Exact Survey of the Cities of London and Westminister* (1746); and Joseph Des Barres's massive volume of coastal charts, *The Atlantic Neptune* (1784). There are thirty-six editions of Claudius Ptolemaeus's (Ptolemy) *Cosmographia*, including the first two woodcut editions from Ulm (1482 and 1486); eight editions of Sebastian Münster's *Cosmographia universalis* before 1630; and twelve editions of various Abraham Ortelius publications, including the 1570 Antwerp edition of *Theatrum orbis terrarum* from the Bridgewater library. The great Dutch mapmakers—the families of Mercator, Hondius, Blaeu, Visscher, and Goos—are well represented. Contemporary published accounts of voyages, navigation and maritime guides, and geographical texts complement these map holdings.

The strengths of the American printed maps reflect the Library's fields of interest—Colonial and Revolutionary-War America, the Trans-Mississippi West, California, and Los Angeles. There is a good selection of maps and geographic works by John Mitchell, Lewis Evans, William Faden, Mathew Carey, Henry Schenk Tanner, David H. Burr, John Melish, S. Augustus Mitchell, Joseph H. Colton, and other influential mapmakers. The California collection is diverse—Gold Rush maps, bird's-eye views, and a wide range of maps documenting the growth of Southern California, including tract, insurance, and land-use maps.

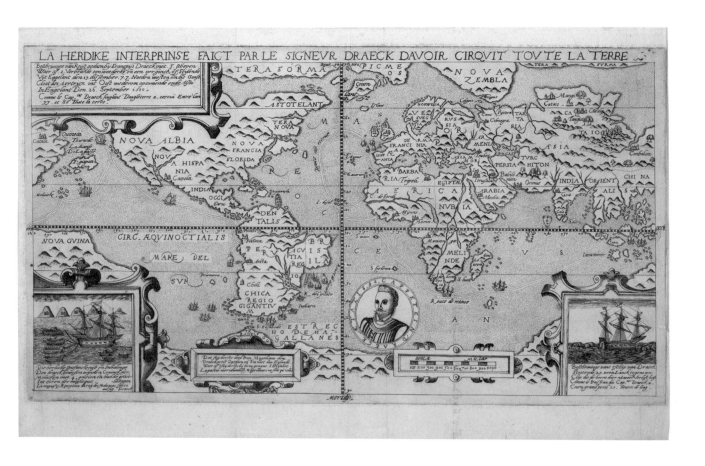

THE DUTCH DRAKE MAP

This unsophisticated map, known as the "Dutch Drake Map," is one of the earliest cartographic depictions of Francis Drake's circumnavigation of the globe between December 1577 and September 1580. There is an oval portrait of Drake and two vignettes showing the *Golden Hind* in Indonesian waters: on the left it is being towed by canoes of the ruler of Ternate, and on the right it is dangerously grounded near Celebes. This unique printing by an unknown cartographer appears to be taken from a map credited to Nicola van Sype. Maps and illustrations occasionally accompanied sixteenth- and seventeenth-century exploration narratives like this account by Walter Bigges of his voyage with Drake.

ABOVE:
"La heroike interprinse faict par le Signeur Draeck d'avoir cirquit toute la terre"
[ca. 1585]
Inserted in Walter Bigges, *Expeditio Francisci Draki equitis Angli in Indias Occidentales* [Leyden, 1588]
Acquired before 1929; RB 9074

THE GREAT DUTCH MAPMAKERS

Petrus Plancius was a minister in the Dutch Reformed Church who became interested in navigation and cartography and produced this world map when the Low Countries were becoming innovative leaders in cartography and printing. It is based on his earlier map of 1590, with important modifications in the East. Korea is shown for the first time in a European map as a peninsula, and the outline of Japan is more accurate. Plancius's map had a widespread influence on other cartographers, and its lavishly illustrated borders presage the elaborate and colorful Dutch-designed maps of the seventeenth century.

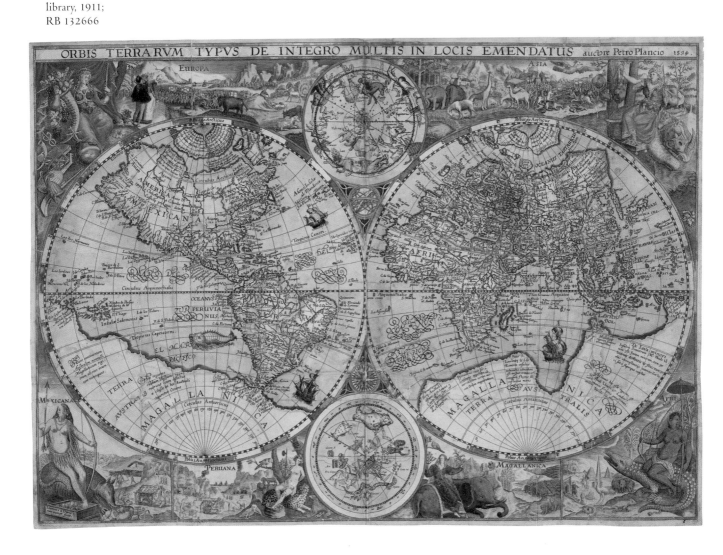

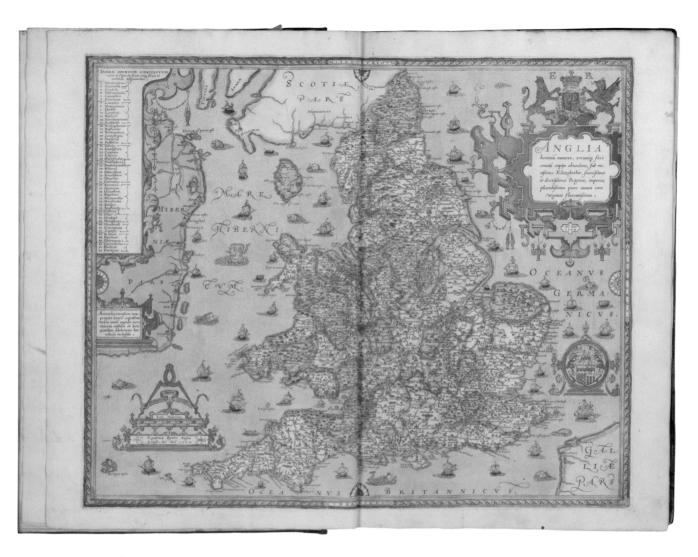

Saxton's Atlas of England & Wales

Christopher Saxton, a land surveyor from Yorkshire, has been called "the Father of English Cartography." From 1574 to 1579 he surveyed the counties of England and Wales, and from this work, thirty-four county maps were engraved. Probably inspired by Abraham Ortelius's seminal atlas of 1570, *Theatrum orbis terrarum*, Saxton brought his maps together as an atlas, adding a frontispiece, an index, coats of arms, a table of towns, and a map of "Anglia." This first English atlas appeared in 1579 and continued to be published for the next thirty years. Saxton's atlas was republished in 1645, 1665, 1693, and 1730 and had a substantial influence on later English atlases.

ABOVE:

Christopher Saxton (1542–1610)?
"Anglia"
Atlas of the Counties of England & Wales
[London, 1599?]
Purchased from the fourth Earl of Ellesmere, 1917;
RB 82871

GLOBES

Joseph Moxon was a hydrographer, printer, and mathematician who became enthralled with map and globe making. In 1659, he wrote *A Tutor to Astronomie and Geographie. Or an Easy and Speedy Way to Know the Use of Both the Globes, Celestial and Terrestrial*. By 1672 he was constructing and selling globes of all sizes, including this rare three-inch terrestrial globe "with the Stars described in the inside of its case." The globe was intended to include the latest geographical information. Moxon stated erroneously that "California is found to be an island," but carefully left out "Terra Incognita" because "we have no certainty whether it be Sea or Land." The Library also has a celestial globe by Jodocus Hondius dated 1600, Blaeu's celestial and terrestrial globes (1602 and 1617), and an armillary sphere by Antonio Santucci (1582 or later).

THE MASON-DIXON LINE

One of the most famous boundaries in American history is the one between Pennsylvania and Maryland, called the Mason-Dixon Line. Because of conflicting English royal grants given to Lord Baltimore in 1632 and William Penn in 1681, a dispute rose over the exact line of demarcation separating the two pieces of land. After a 1760 agreement was reached among claimants, the English surveyors Charles Mason and Jeremiah Dixon surveyed the area for four years and located the line at 39 degrees 44 minutes north latitude. Their survey was published separately in a two-part map; one part is shown here. Before the Civil War, the Line became the dividing line between slavery and free soil, symbolizing the political, cultural, and social separation between North and South.

FIRST BATTLES OF
THE AMERICAN REVOLUTION

The military battles between the British and
Provincials at Lexington and Concord, which
occurred on April 19, 1775, marked one of the
seminal events in United States history. On that
day British Lt. Colonel Francis Smith marched
out of Boston with a detachment of 700 regular
troops to destroy the military stores at Concord.
He first engaged the minutemen on the Lexington
Green and again at the North Bridge in Concord.
Returning to Boston, the British regulars were
under constant fire and were saved only by the
reinforcements of Sir Hugh Percy and the safe
haven at Charlestown. This rare De Costa map,
printed in London, depicts these first battles of
the American Revolution. Nothing is known of
De Costa, but his work illustrates the battles, the
British return, and the minutemen reinforcements
coming from the North. Forty-nine Americans
and seventy-three British were killed on April 19.
Almost 4,000 American militia saw action, and this
tenacious response proved that they could fight the
British on their own terms. It immediately resulted
in the siege of Boston and the authorization of
troops by the provincial Congress.

First U.S. Road Map

This *Survey*, published in 1789, is considered the first systematic series of road maps of the United States, although it by no means covers all of the roads of the new republic. It was created by Christopher Colles, who emigrated from Cork, Ireland, in 1771 to Philadelphia and for much of his life promoted visionary but ill-fated projects, including the construction of a waterway joining the Great Lakes and the Atlantic Ocean. In the initial proposal and subscription for his *Survey*, Colles stated that he wanted to provide an accurate and practical traveler's guide to roads by preparing 100 strip maps, each covering twelve miles and identifying important geographical features and places such as taverns and blacksmith shops. In the end, only eighty-three plates were executed for the book. The entire series covers about 1,000 miles from Albany, New York, to Williamsburg, Virginia. This was an imperfect but first attempt in a long history of mapping American roads.

First Map of Hollywood

The Southern California land boom of the 1880s created many of the communities that still exist today. In the frenzy of the era, promotional tract maps were important in selling the merits of the region. The first map of Hollywood produced by H. H. Wilcox & Company in 1887 is one of the finest examples of this genre. Harvey Horace Wilcox and his wife Daeida (Ida), the founders of Hollywood, were ardent Methodists and temperance advocates who envisioned establishing an upright Christian community below the Santa Monica Mountains. Ida named the town, and her husband developed it. When Hollywood was incorporated in 1903, it had a population of 700; by the time of its consolidation with Los Angeles in 1910, it had a population of 4,000. Thereafter, it was transformed into the movie capital of the world. In the Wilcox map, the central feature of the new development of Hollywood is the Hollywood Hotel. On the coast is the City of Santa Monica, and below that, Ballona Harbor—now Marina del Rey.

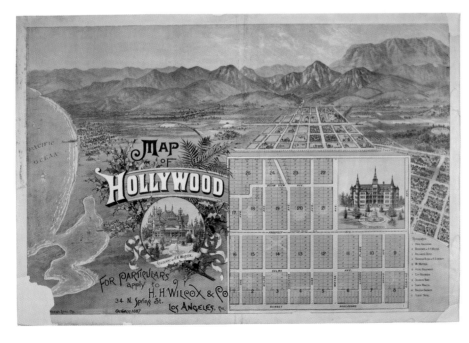

MAPS AND POLITICS

The People's Independent Party sprang up in the early 1870s in California as a largely pro-farm movement. The organization created the map shown here as a campaign tool, in order to stir up voters and to promote its argument that the Southern Pacific and other railroad corporations had enormous economic and political power and were devastating the state of California. The map purports to show federal lands granted to the railroads in the 1860s to encourage building. (Yellow areas indicate outright grants; the adjacent red sections are indemnity strips as an alternative if other parcels were not available.) At first glance, it looks as if the railroads owned half of California. In actuality, the map is full of major distortions or cartographic lies. It exaggerates the amount of land that was granted, delineates strips of land that were never given, and includes rail lines that were never built. Despite the obvious distortions, this map continues to be used by historians to prove a California legend—that monstrous railroads and their robber barons received an enormous land handout from the federal government.

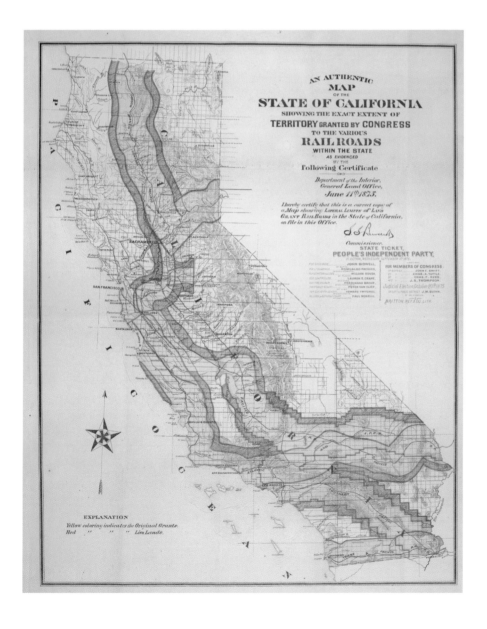

LEFT:
People's Independent Party (California) "An Authentic Map of the State of California Showing the Exact Extent of Territory Granted by Congress to the Various Railroads Within the State" [San Francisco: Britton, Rey & Co. Litho., 1875] Purchased from Argonaut Bookshop, 1960; RB 338918

Research and Education

Huntington was aware that scholars were interested in his collection. He always allowed them access to his library, even inviting them to his New York City home. In 1919, after the collections were moved to California, he created an institution that included the Library holdings as well as his mansion and gardens. He issued a policy statement in 1925 indicating his high aspirations: "The international reputation of the Huntington Library and Art Gallery and its value to the world will depend chiefly upon what it produces." To carry out this lofty mission, the Huntington should ensure "the best utilization of its unique contents by the methods successfully employed in other research institutions, such as. . . the British Museum," which sponsored research and published the results in journals and books. Such a goal was ambitious indeed for an infant institution far away from the universities and cultural centers of the East coast.

With these high aspirations, the Huntington set out to function like other famous institutions. Max Farrand, a distinguished historian of the American Revolution, was appointed the first Director of Research. Farrand, in turn, immediately brought in Frederick Jackson Turner, the most famous American historian of his day, as the first resident scholar.

Nearly eighty years later, the Huntington is still engaged in the same mission. Now, however, instead of a handful of resident fellows, some 2,000 scholars from around the world visit the Library, staying for a few days, a few weeks, or for an academic year. Endowments and foundation grants support

FAR LEFT:
Huntington Library exterior

LEFT:
Ahmanson Reading Room

approximately 130 researchers in residence. Sponsoring academic conferences that have presenters from around the globe is another way in which the institution acts as a catalyst to advance learning in the humanities.

In addition, scholars from nearby universities attend classes at the Library to learn about working with rare materials, the history of the book, and paleography, the study of ancient handwriting. An active lecture program brings leading scholars to community audiences, advancing popular knowledge of the humanities.

The Huntington also assists in the creation of new fields of study. During the 1940s, the Rockefeller Foundation financed a program to further the study of the history of California and the Southwest. The seminars and workshops sponsored by the program trained a generation of young scholars who went on to distinguished careers. The Huntington has an ongoing commitment to this field today and, as an example, is now compiling a database of all of the sacramental records from the California missions. Soon, scholars will have an important tool for building a more accurate picture of the state's past.

In 1920, the Huntington published its first books, the beginning of a steady flow of editions, monographs, facsimiles, and catalogs drawn from the collections. Subsequently, it established the *Huntington Library Quarterly*, which has been making contributions to scholarship for more than sixty years.

When Huntington stated that his Library's "value to the world" would depend not on the mere scale and magnificence of its collections, but on what was created from them, he could hardly have dreamed that the reading rooms would produce some of the most important works on British and American history and literature in the past eighty years. As Huntington himself said, "The library will tell the story. It represents the reward of all the work that I have ever done and the realization of much happiness."

RIGHT:
Books published
by the Huntington
Library Press

Index